IMAGES of America
POINT REYES PENINSULA

OLEMA, POINT REYES STATION, AND INVERNESS

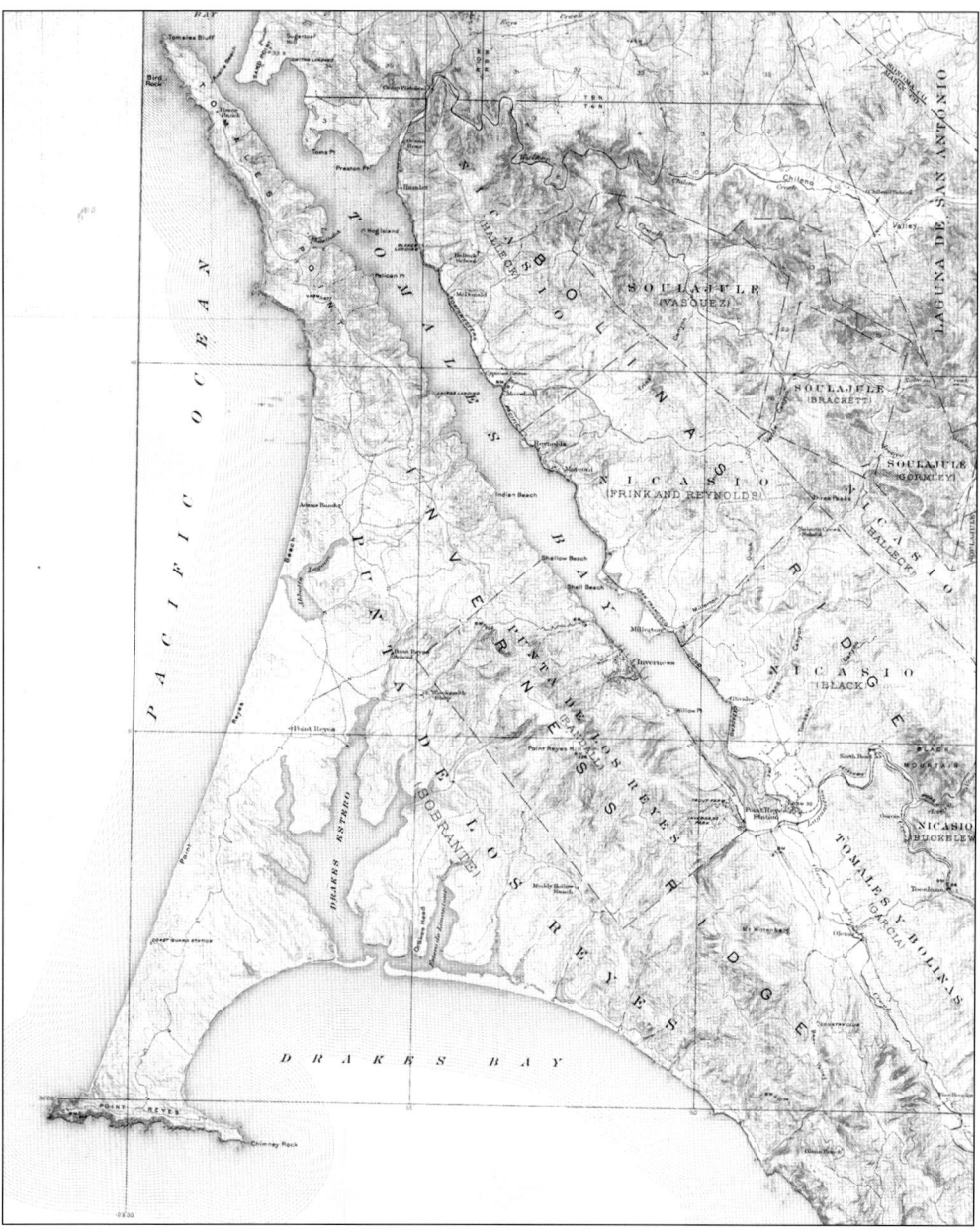

The U.S. Geological Survey released the first complete topographic map of the Point Reyes area in 1918. It shows the early location of roads, railroad tracks, and developing communities in the Tomales Bay area. (Jack Mason Museum.)

ON THE COVER: These two modern travelers descend into Point Reyes Station in 1914, a time the town was undergoing a growth spurt. A milk processing factory, a community hall, and a two-story brick mercantile/hotel would appear along the Northwestern Pacific tracks within the following year. The distinctive Black District School rises in the distance at right. (Point Reyes Library.)

IMAGES of America
POINT REYES PENINSULA
OLEMA, POINT REYES STATION, AND INVERNESS

Carola DeRooy and Dewey Livingston

Copyright © 2008 by Carola DeRooy and Dewey Livingston
ISBN 978-0-7385-5848-6

Published by Arcadia Publishing
Charleston SC, Chicago IL, Portsmouth NH, San Francisco CA

Printed in the United States of America

Library of Congress Catalog Card Number: 2008921000

For all general information contact Arcadia Publishing at:
Telephone 843-853-2070
Fax 843-853-0044
E-mail sales@arcadiapublishing.com
For customer service and orders:
Toll-Free 1-888-313-2665

Visit us on the Internet at www.arcadiapublishing.com

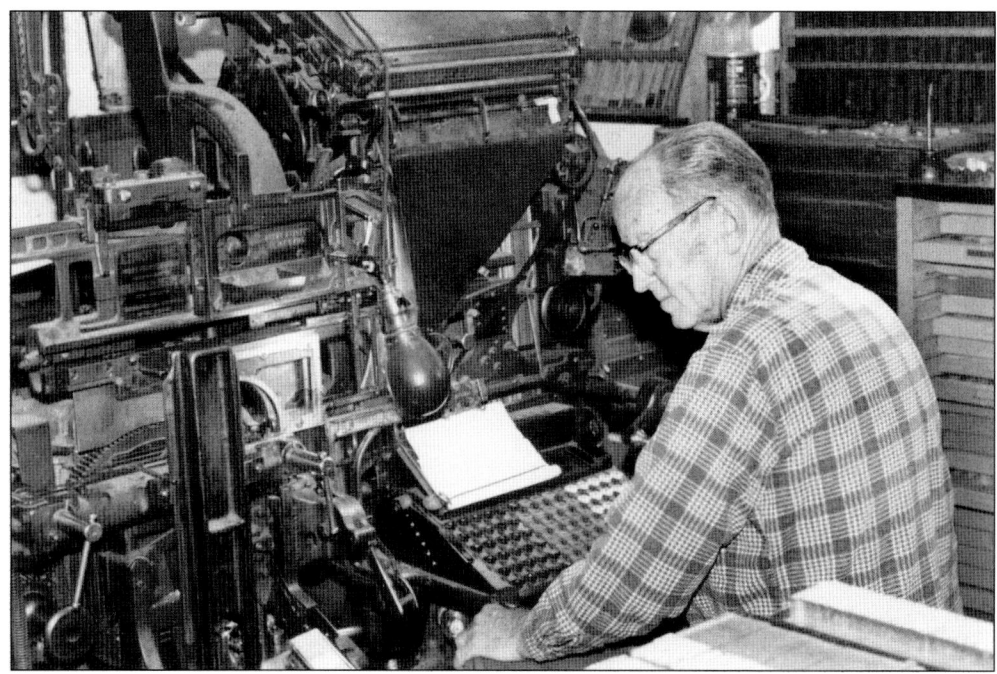

Jack Mason served as the historian of the Point Reyes region for the last two decades of his life. His connection to the area originated when his grandmother purchased a lot in Inverness in the 1890s, and Jack's boyhood was filled with the smells of Bishop pine pitch and saltwater. Upon retirement as a senior editor at the *Oakland Tribune*, Jack settled down in his historic house, The Gables, and commenced interviewing old-timers and collecting photographs and ephemera that documented the history of Point Reyes. He wrote eight books and published a quarterly, *Point Reyes Historian*. At the time of his death in 1985, Jack had arranged for the public purchase of The Gables and left his collection to the Inverness Foundation, which today operates the Jack Mason Museum of West Marin History, an archive and exhibit area within the Inverness Library.

Contents

Acknowledgments 6

Introduction 7

1. Natives and Newcomers 9
2. Cow Heaven 23
3. Wayfaring by Sea and Land 47
4. Town and Country Life 69
5. An Invigorating Landscape 99
6. A National Park Arrives 113

ACKNOWLEDGMENTS

The most challenging aspect of compiling this book was choosing from so many wonderful pictures. The thousands of images that we didn't use testify to the rich archival resources in our community that are available to all of us. The authors wish to acknowledge the many people who contributed to our efforts in creating this book. The Jack Mason Museum of West Marin History offered unrestricted access to the collection. We thank the Museum Committee of the Inverness Foundation for permission to use the extraordinary resource, originally collected by West Marin historian Jack Mason. We also wish to thank Point Reyes National Seashore for the use of their collection materials. Our gratitude goes to the following individuals, who allowed their private collections to be mined and who supported our efforts in other significant ways: Dan Brown, Dr. Jeffery Burns of the Chancery Archives, Al Clarke (in memoriam), Patricia Clark, Mark Davis, Jesse DeRooy, the Eastman family, Betty and Jon Goerke, D. M. Gunn (in memoriam), Jim Kravets, Kirsten Kvam, Kerry Livingston, Patricia Lyon, the McIsaac family, Kathy Meier, Mimi Menzies, Jocelyn Moss at the Marin History Museum, Lee Murphy (in memoriam), Lucian Myron, Elisabeth Ptak, Steve Quirt, Wende Rehlaender, Art Rogers, Ralph Shanks, Susan Snyder at the Bancroft Library, the Stewart family, Amanda Tomlin, Dick Velloza, and M. Woodbridge Williams. We also appreciated the prodding and patience of our editor, John Poultney. Unless otherwise credited, photographs, maps, and graphics reproduced in this book are from the collection of the Jack Mason Museum of West Marin History. Many other images are drawn from the archives at Point Reyes National Seashore, a unit of the National Park Service, and are credited "PRNS Archives." Other private collections and photographers are credited in the captions accompanying the images.

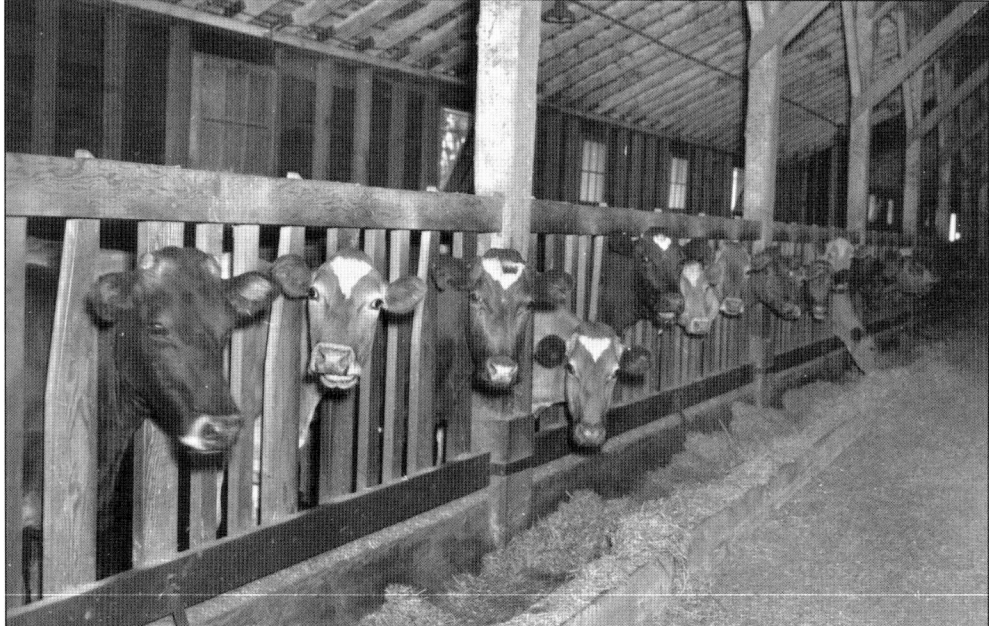

The Point Reyes story centers around the humble cow. Without cows, the Point Reyes Peninsula would now likely be covered in tract homes, indistinguishable from any other California suburb. Generations of tenacious dairy ranchers supported the local economy and kept the land undeveloped, which laid the groundwork for preservation in the form of parks, agricultural easements, and conservation- and agricultural-oriented zoning.

INTRODUCTION

Point Reyes has famously been called an "Island in Time," an allusion to its geological history (and future) and the almost-pristine state of its natural and historical landscape. Separated from the "mainland" by the San Andreas Fault, the Point Reyes Peninsula is inching its way to the northwest to eventually end up as an island. To look at a map of the California coast, Point Reyes stands out as a unique, sometimes animalistic shape facing outward, and the razor-slice of the fault line makes one wonder if it had been cut and pasted onto the map with a piece from some other region.

Looking more closely, Point Reyes is covered in a variety of coats: beaches, sand dunes, grasslands, chaparral, and forests, all giving way to each other as the soil below and climate above make their discreet changes. Early visitors remarked on the weather (foggy), the soil (rich), the pasture (valuable), the location (remote), the scenery (beautiful), and the general environment (pleasant). All of these characteristics have had their say in the history of Point Reyes Peninsula. Families arrived with cows to eat the grass, which the summer fogs made more nutritious; farmers planted potatoes, beans, peas, and artichokes in the rich soil; and people came here to visit, play, and live because the place was beautiful and pleasant and yet untrammeled because of its remoteness.

And so, on this funny-shaped peninsula practically surrounded by water, we find dairy and cattle ranches, farms, parks, permanent and summer homes, quaint towns, winding roads, and a generally satisfied small populace. It is far from civilization but close, only an hour or so from San Francisco. The core of the old-timers remains because it is still a rich agricultural region. Most others moved here because they truly fell in love with it. Tourists return again and again to walk in the peaceful glens, eat fresh oysters, or sleep in a quiet cabin in the trees. Everyone will agree: it's a special place on earth.

The Coast Miwok made Point Reyes their home until being rudely moved aside by newcomers. The same story happened all over the growing United States, and here it was almost complete: the remaining Native Americans moved north or laid low, working in local industries, for the most part without their own land. Only recently has the tribe been recognized by the federal government and is now organized and growing. Their successors, the Mexican land grantees, have left no known descendants in West Marin.

When California became a state in 1850, and Marin a county, Point Reyes remained a remote outpost. No roads approached the area, so most visitors arrived by sea. The rich grasslands attracted forty-niners who left the mines for the life of a farmer, raising dairy cows and making butter, filling the needs of a rapidly expanding San Francisco. So complete was the takeover by dairying that literally every acre of pasture was fed upon to make the premium golden butter. The local timber was of little value and no gold to speak of was found in the hills, so the dairy industry dominated this land, called by one of the pioneers "Cow Heaven." Point Reyes made the best butter San Franciscans had tasted and spawned a dairy industry that now sees California as the top in the nation.

With the ranches came immigrants from Ireland, southern Switzerland, Denmark, and the Portuguese Azores. These families became the backbone of the hardworking culture of Point Reyes, bringing a strong moral ethic and a determination to be successful in their new country. And succeed they did, as the signs on the driveways to the ranches prove. The ranches are the major part of the heritage of the area and are central to today's historic movement for healthy and locally produced food as the fifth generation now branches out into organic dairy milk, pasture-fed beef and chickens, and artisan products.

While cows and their keepers dominated Point Reyes history, many other industries and occupations also left their imprint. Entrepreneurs built a railroad line that edged past Point Reyes, spawning a handful of small towns and affording a way for local residents to travel and ship their products. The U.S. government mapped the shores and established facilities to aid the ships'

captains as they navigated this treacherous shore. The Point Reyes Light Station, built in 1870, served the mariners and now attracts thousands of visitors while still shining brightly. The Point Reyes Life-Saving Station, a rather obscure but important operation, saved lives for almost 40 years. When it was succeeded by the Point Reyes Lifeboat Station in 1927, the brave men continued for another 40 years to crash into heavy seas in order to aid the stranded boat or ship.

The government also operated radio communications on the point, usually to report weather conditions and emergencies at sea. Commercial communications arrived with a blast of wireless signals across the Pacific from the Marconi Wireless Company of America's stations, built in 1914 and succeeded by RCA Communications in 1920. The dedicated operators tapped their keys until recently in the name of safety, news, correspondence, and information.

The pastoral world of the Point Reyes Peninsula got a taste of postwar "progress" in the 1950s as planners and land developers looked afar from San Francisco in search of locations for the next bedroom communities. Point Reyes offered thousands of acres of open land, and with good freeways, a commuter could reach the city in less than an hour. Engineers laid out those freeways on paper, and others platted the land and drew building lots, roads, sewer systems, and power poles while providing names like Paradise Ranch and Drake's View. Loggers built sawmills in the Olema Valley and felled Douglas fir and redwoods, more than had been cut in the century before. Many Bay Area residents became alarmed.

As the suburbs swallowed up the pastoral beauty of the Bay Area beginning in the 1950s, more and more people came to believe that certain areas should be preserved in their natural state. Point Reyes became a focus of the conservation movement. The National Park Service proposed a large new national seashore at Point Reyes, which brought waves of support in the region and cries of protest locally. Congress listened to both sides and arrived on a compromise that would allow the traditional ranchers to stay while the park was developed and opened to the public. Pres. John F. Kennedy signed the bill that created Point Reyes National Seashore in September 1962. He was assassinated just as he was planning a visit to the magical place he had heard so much about.

Today the Point Reyes Peninsula and its towns offer diverse recreational and educational opportunities, as those beaches, sand dunes, grasslands, chaparral, and forests remain almost as they did 200 years ago. Local residents make their livings in many ways, from producing food to telecommuting. Most work regular jobs at the bank, store, or parks. Point Reyes is now well known, attracting new residents (although the housing market is sparse) and visitors to this very special place on the California coast.

One

NATIVES AND NEWCOMERS

Ancestors of the Coast Miwok were the first people who lived in the vicinity of the Point Reyes Peninsula, approximately 3,000 years ago. For centuries, until the arrival of Europeans, they lived lightly on the land, using, renewing, cultivating, and trading the abundant resources found on this three-sided island with a moderate climate. There is little or no evidence that they practiced warfare; the materials that remain—large mortars of stone; hand-shaped tiny shell beads; intricately carved whale, bird, and deer bone; expertly flaked obsidian; feather headdresses; and tightly woven baskets—speak of a patient people. Decades before the *Mayflower*, Sir Francis Drake reported friendly Native Americans on these shores in 1579. Drake was the first of several explorers to claim the Coast Miwok lands for their own country. He was preceded by Cabrillo and followed by Cermeño and Vizcaino, who all claimed the land for Spain. After Vizcaino, 150 years elapsed before the Spanish returned, discovered San Francisco Bay, and constructed military presidios and missions. Many Coast Miwok were coerced and driven to become laborers at San Francisco and San Jose missions, but disease quickly caused them to fall ill or perish. With the establishment of Mission San Rafael de Archangel in nearby San Rafael as an *assistencia*, a hospital mission, several hundred Coast Miwok were moved back nearer their homeland. The mission system began deteriorating when Mexico won its independence from Spain and gained possession of California in 1821. The Miwok lands then came into possession of Mexican loyalists like Raphael Garcia, who were rewarded with large tracts on which to raise cattle and crops. Some of the Miwok fled back to Point Reyes to work on ranchos. By that time, their tribal traditions were forever shattered. Today the Coast Miwok are a small, federally recognized band relearning their language and carrying remembered traditions into the future. The peninsula was divided into several land grants, with Garcia and several others trading and selling land without proper deeds. In 1851, shortly after California achieved statehood, land grantees were required by a new law to prove ownership of their land or *diseño*. Years of litigation wore down Garcia, and others sold out. This ushered in the perfect opportunity for wealthy American lawyers from the East, including the Shafter brothers, to acquire vast tracks of land now hopelessly lost to the original inhabitants and those who had displaced them.

Tomales Point, the northern tip of the peninsula, is bounded by the Pacific Ocean to the west and Tomales Bay to the east. A large Coast Miwok village, *olema-loke*, was located at the head of the bay near freshwater creeks and marshes with plentiful fish and game. Villages on the east shore of the bay, *echa-kolum*, near the town of Marshall, and *sakloki shotomko-wi*, farther north on the bay, were ideally situated for collecting abundant shellfish at low tide and trading with inland tribes. (PRNS Archives.)

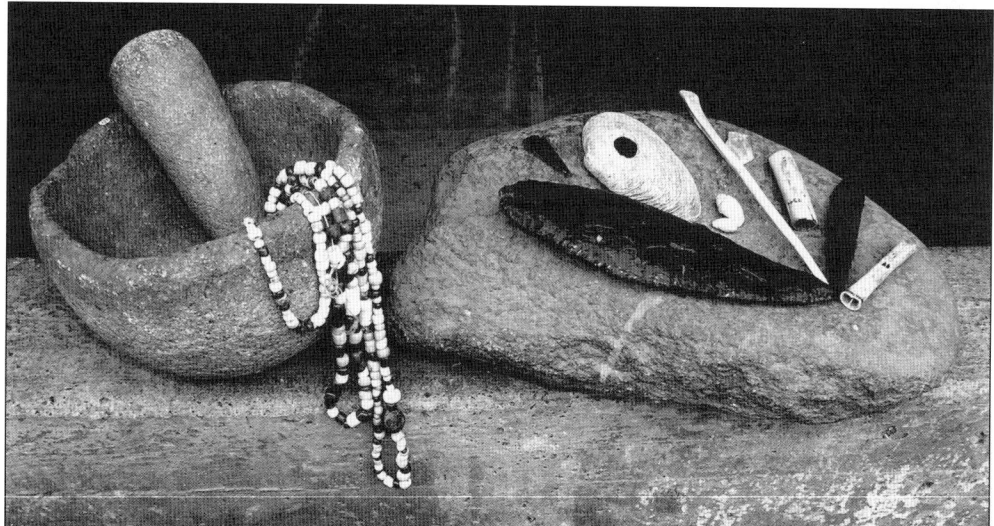

Material culture of the Coast Miwok excavated at Point Reyes includes, from left to right, a mortar and pestle for grinding acorns, strung beads, a flat grass seed mortar on which is resting a large obsidian knife, a fine arrow point, a clamshell with bead blank cut out, olivella shells, a bone awl, a shaped abalone shell, an incised bone tube, a spear point, and a bone whistle. (PRNS Museum Collection.)

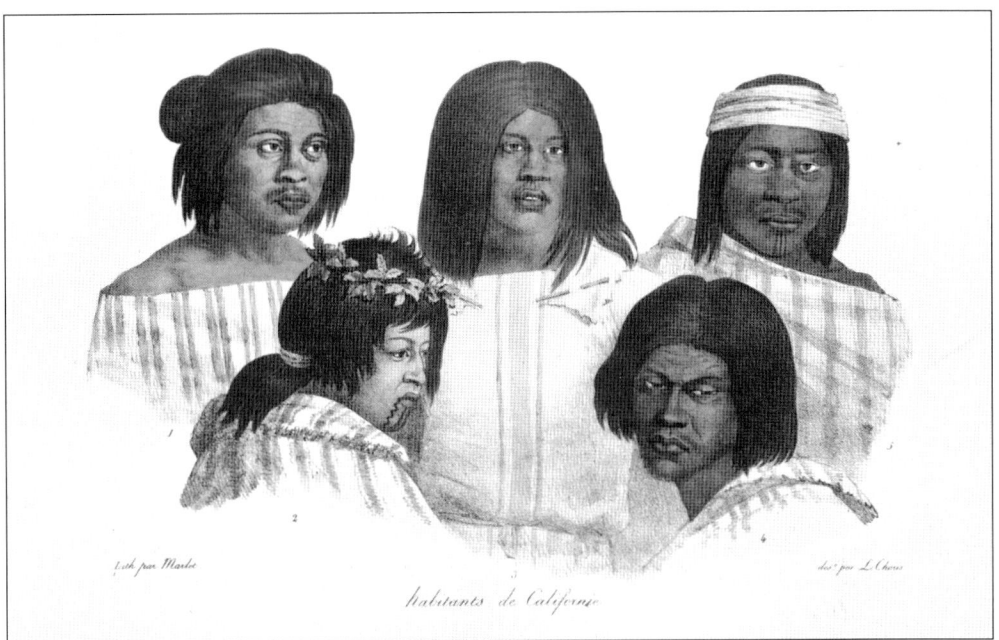

Artist and explorer Louis Choris (1795–1828) was aboard the Russian ship *Ruric* in 1816. He produced a number of fine paintings of Bay Area Indians while the Russians and Spanish negotiated political alliances for a month at the Mission San Francisco de Asis. The two figures in the front of this portrait are Coast Miwok. Note the *hotca-oni*, or face tattoo, on the woman, which was traditionally applied when she reached puberty. (Bancroft Library.)

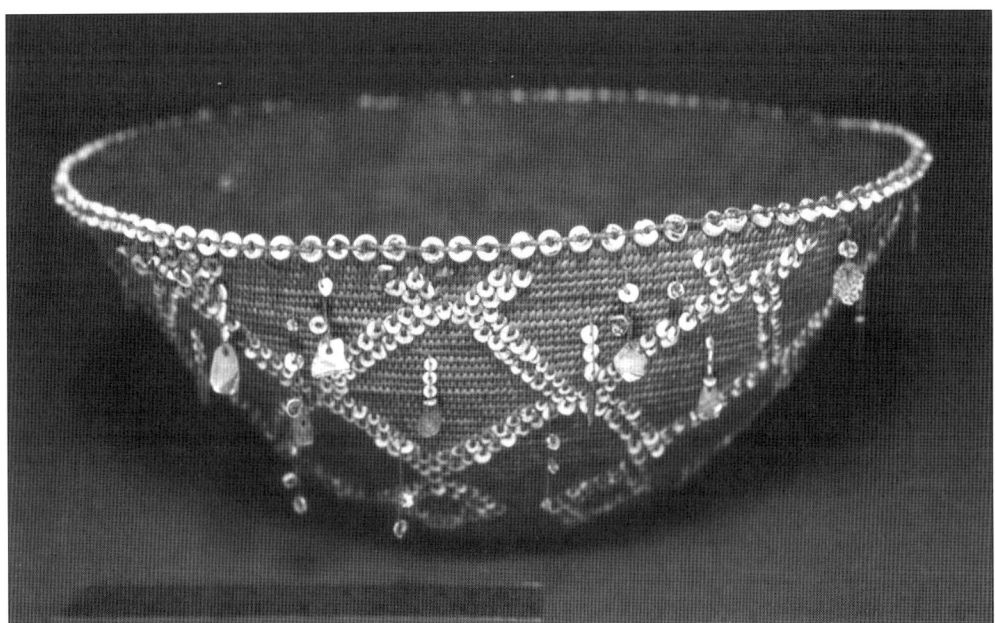

This twined basket has a sedge root weft and an up-to-the-right slant twist distinctive of Coast Miwok basketry. Abalone pendants are centered in a diamond pattern formed by olivella shell disk beads. Thicker clamshell disk beads decorate the basket rim. (Staatliches Museum fur Volkerkunde, Munich, No. 142; photograph by Jon Goerke.)

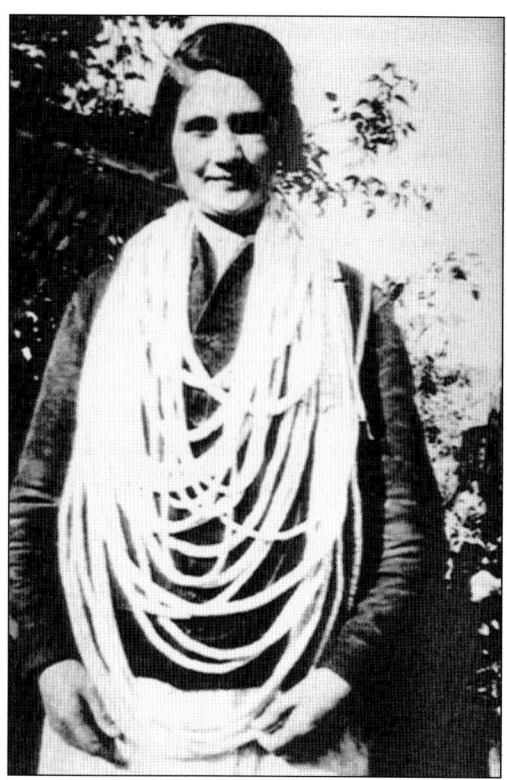

Rosalie Smith Coady (1893–1978) displays the clamshell beads made by her father, Bill Smith. A measure of exchange and wealth for the Coast Miwok, clamshell beads paid for privilege, luck, instruction, ceremonies, dances, and other services.

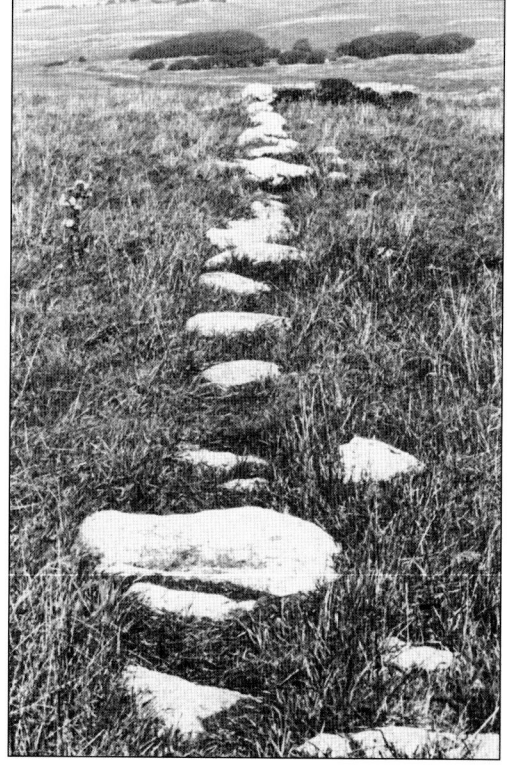

Today hikers encounter this 820-foot-long row of granite stones about 1.5 miles along the Tomales Point trail. The boulders are aligned to Mount St. Helena in the northeast and run to the cliff edge, pointing to the Farallon Islands in the southwest. They are named the Spirit Jumping-Off Rocks by the Coast Miwok tribe, who believe when a person dies their spirit walks west. The rock line is man-made and appears on an 1862 Coast Survey map, just four years after Solomon Pierce began ranching on the point. However, who placed the stones, for what purpose, and when still remains uncertain. (PRNS Archives; photograph by D. M. Gunn.)

Sir Francis Drake was the first Englishman to circumnavigate the globe and to set foot on the California coast in 1579. Drake plundered Spanish ships en route to North America, where he searched unsuccessfully for a northwest passage. The pirated fortune bestowed upon Queen Elizabeth I earned Drake a knighthood shortly after his return to England. His diary and maps from the three-year journey were secreted away by the monarch and have not surfaced in the four intervening centuries. (PRNS Archives.)

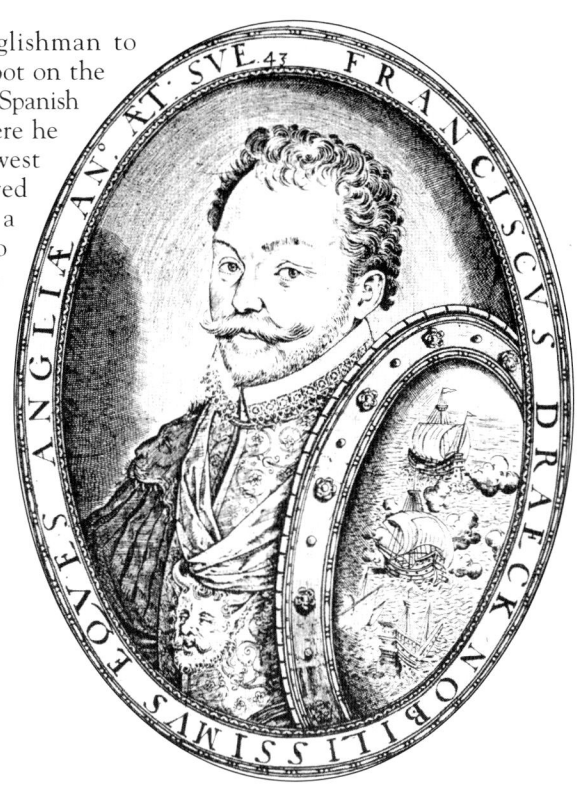

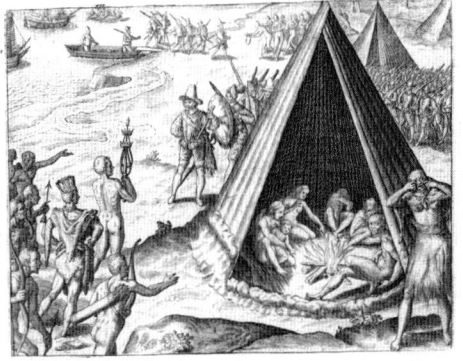

Anxious to supply and repair his ship to return to England with treasure, Drake anchored inside a "faire and good Baye" at Point Reyes on June 17, 1579. This image depicts the hundreds of Coast Miwok gathered to celebrate Drake's arrival with great ceremony. This bookplate, published 11 years after Drake sailed back to England, presented the first images of Native Americans to Europe. (Bancroft Library.)

This map is an inset of a larger world map known as the Hondius Broadside of 1595, illustrating Drake's California port at 38 degrees north. Drake claimed the lands for England and named them Nova Albion. He never published anything about his voyage. However, using maps and other written accounts, scholars still debate the exact landing site among bays along the Marin coast. Most agree Drakes Bay and Estero, on the Point Reyes Peninsula, are the sites where Drake and his men camped for six weeks in the summer of 1579.

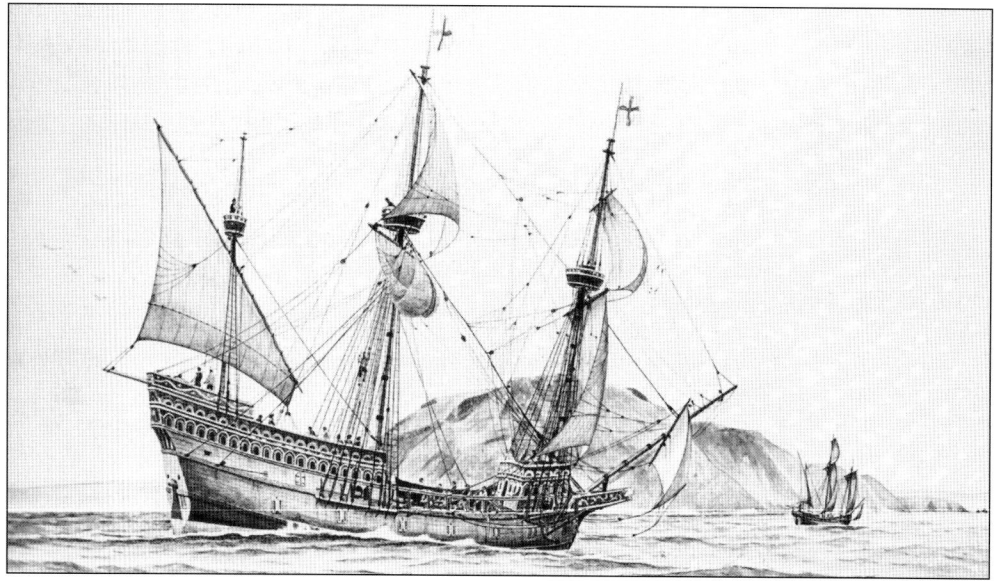

On his circumnavigation, Drake changed the name of his ship from *Pelican* to the *Golden Hind* to honor one of his sponsors as he entered the treacherous Strait of Magellan. This drawing illustrates the *Golden Hind* and her tender rounding Point Reyes head. (PRNS Archive; drawing by Raymond Aker.)

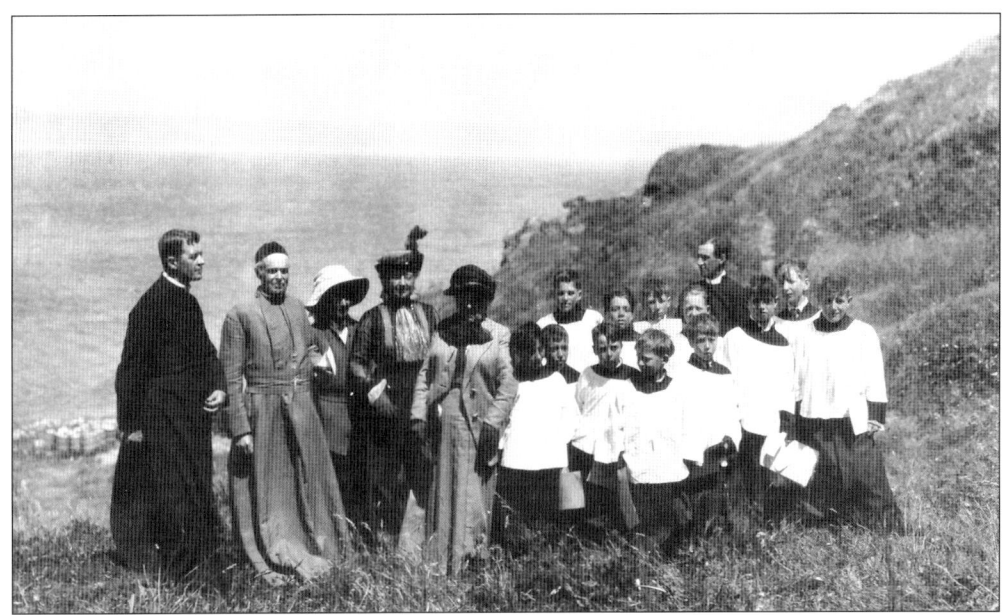

Early U.S. coast surveyor and historian George Davidson believed Drake's landing site to be the cove at the present site of the Coast Guard Lifeboat Station in Drakes Bay. In commemoration, the newly formed Sir Francis Drake Association held their first annual meeting above the cove in June 1914. In attendance were such notables as, from left to right, Rev. Irving Spencer, bishop of California William Nichols, Josephine Hyde, archaeologist Zelia Nuttall, and Mrs. Charles (Emma Shafter) Howard, along with a boy's choir.

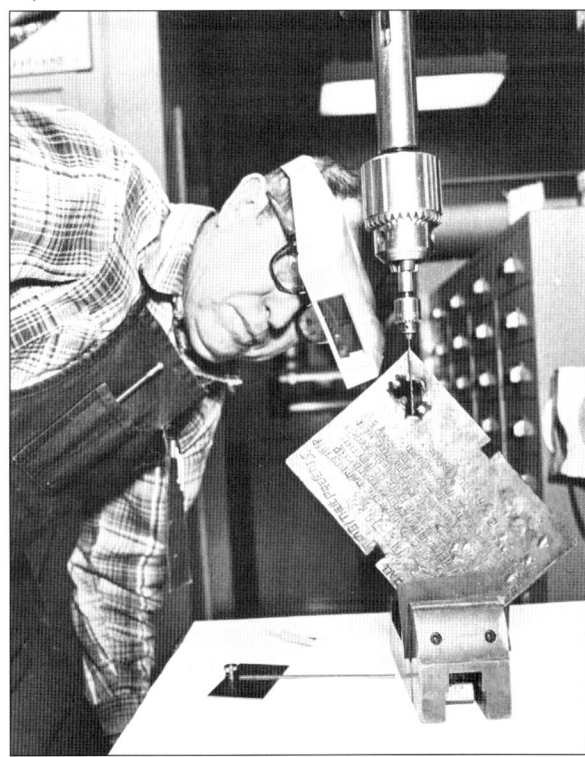

On his departure, Drake formally signified his claim to Nova Albion for England by nailing upon a "faire great post," a crudely inscribed brass plate. Found in Marin in 1936, the plate was authenticated. However, in 1977, extensive tests at Oxford, MIT, and the Lawrence Berkeley Laboratory (shown here), and in 1991 at UC Davis, concluded the lettering, metal composition, and manufacturing techniques were of the 19th and 20th centuries. (PRNS Archives.)

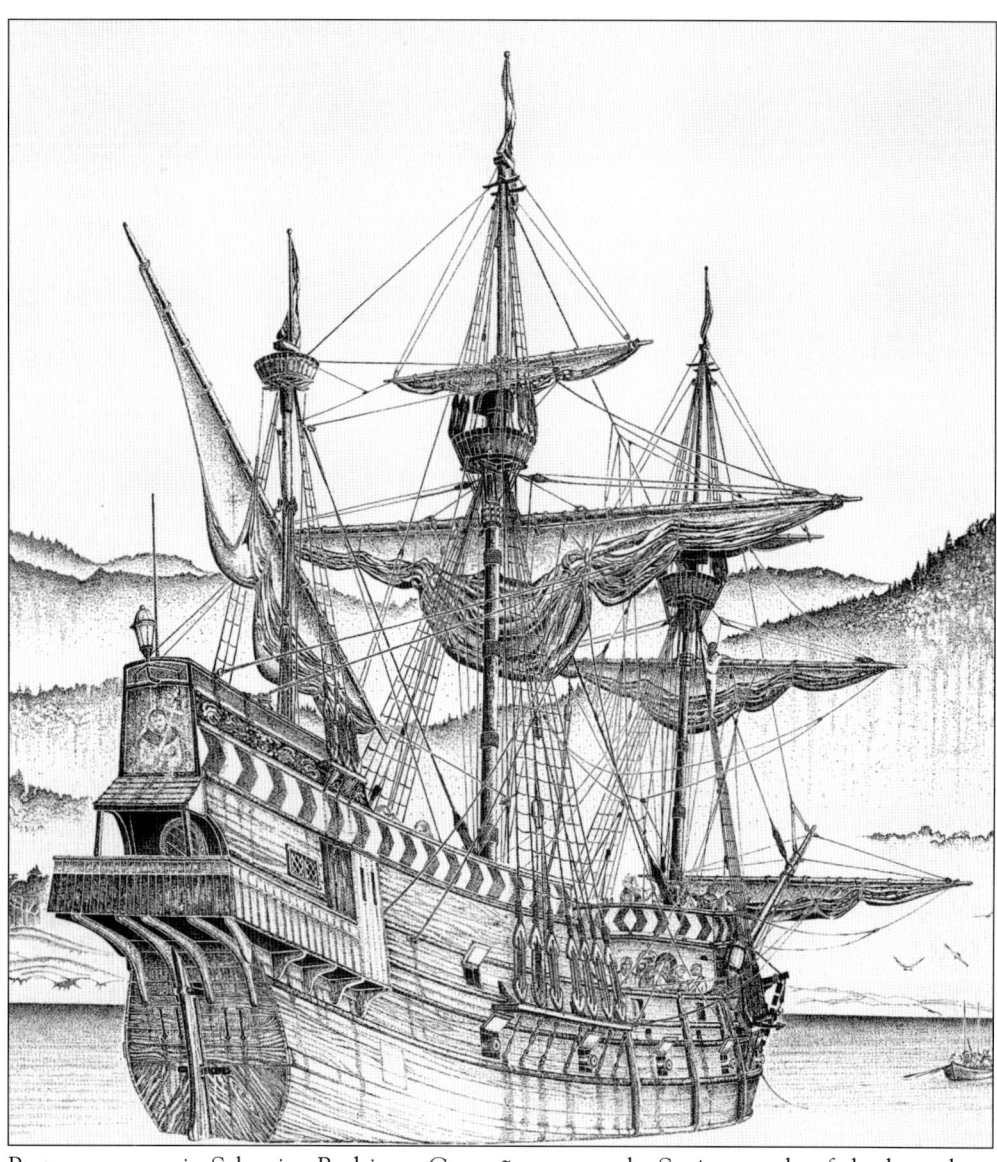

Portuguese captain Sebastian Rodriguez Cermeño was sent by Spain to seek safe harbors along the California coast for the Manila galleon trade. Cermeño safely piloted the 200-ton, fully loaded galleon *San Agustín* into Drakes Bay in November 1595. Cermeño claimed the lands for New Spain, but ashore while gathering supplies, disaster struck. A squall from the southwest caused the galleon to be driven ashore and broken up in the pounding surf. Stranded and with the cargo lost, the captain and 70 men sailed their small launch, *San Buenaventura*, back to Mexico. (Drawing by Lucian Myron.)

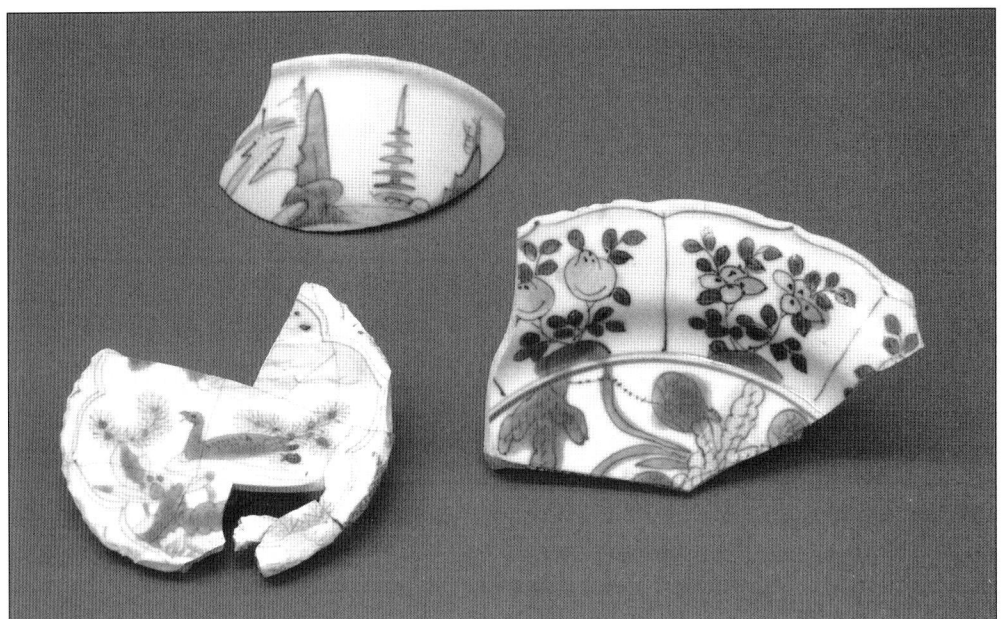

These cobalt-blue and white porcelain shards, excavated from a Coast Miwok midden near Drakes Bay, are either part of the *San Agustín* cargo or were left behind by Drake. Many of the same family-run porcelain factories in China where these pieces originated in the mid-1500s are still in business today. (PRNS Museum Collection.)

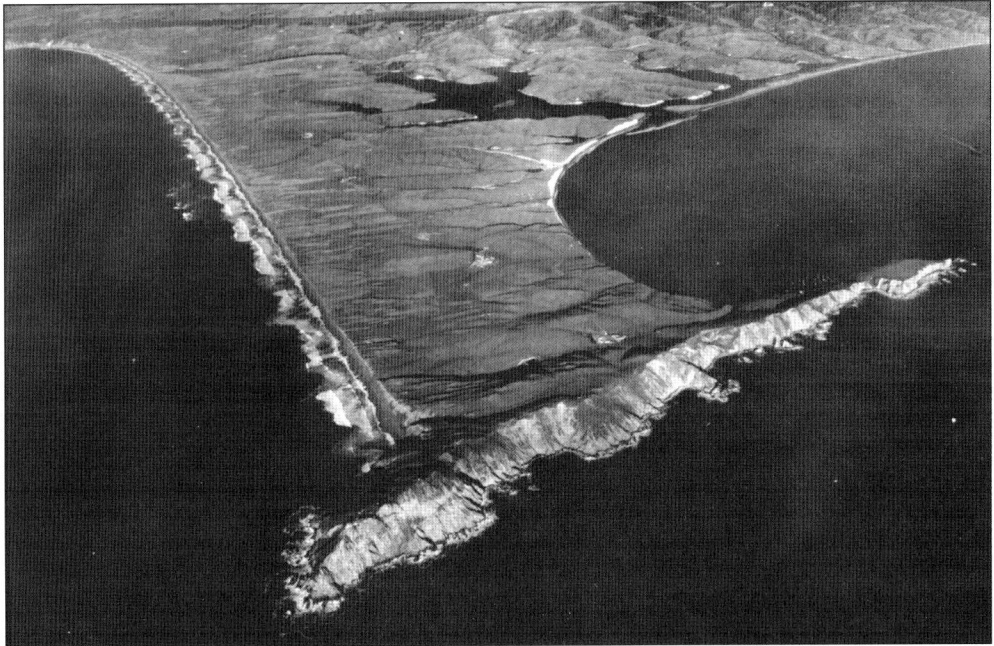

Explorer Sebastian Vizcaino anchored his ship, the *Capitana*, in the southwest corner of Drakes Bay on the Day of the Three Kings, January 6, 1603, the Roman Catholic feast day of the three wise men. Following Spanish tradition, Vizcaino named the double-pointed peninsula after these religious figures: "La Punta de los Reyes" or the Point of the Kings. To California settlers, it became known as Point Reyes. (PRNS Archives.)

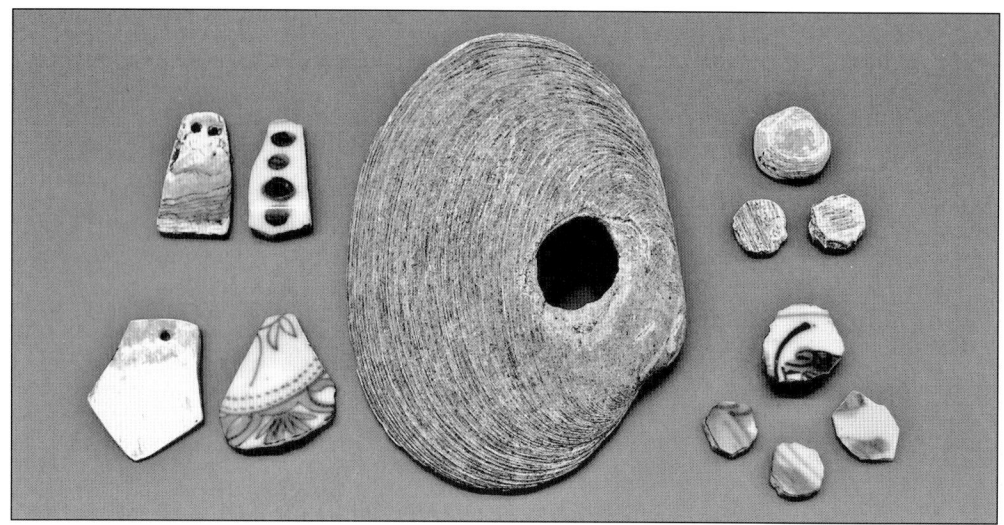

Through shipwrecks and trade with early explorers, the Coast Miwok were among the first native people in North America to possess materials like porcelain, glass, and iron manufactured in Asia and Europe. Shown are rare pieces of patterned, mid-16th-century Chinese Ming Dynasty porcelain worked into traditional shapes—like clamshell bead blanks (center and right) and abalone pendants (left). All of the materials shown were excavated on Point Reyes by archaeologists in the 1960s. (PRNS Museum Collection.)

Mission San Rafael Arcángel was built in sunny San Rafael as an *assistencia*, a helper mission and hospital. Disease and unsanitary living conditions caused alarming death rates to Native Americans confined to missions in San Francisco and San Jose. In 1817, about 240 Coast Miwok returned to their native area and Marin's new mission to recover. In following years, Fr. Juan Amorós did not wait for more converts to come to the Mission San Rafael. In his zeal to convert neophytes, he traveled to villages at Tomales Bay and Point Reyes to baptize Coast Miwok unable or unwilling to come to the mission. (Marin History Museum.)

During the first mass at Mission San Rafael Arcángel, December 14, 1817, twenty-six native children were baptized and given Spanish names by Fr. Vicente Francisco de Sarria. This baptismal record for the 14th child that day reads; "Another [child] about 24 months old, called Vyuta, child of Chalguatti of the rancheria of Xegloque and Ottacatemoc of Pattai: I give the name of Santiago." (Chancery Archives, Archdiocese of San Francisco; photograph by Marvin Collins.)

In 1836, Rafael Garcia received Rancho Tomales y Baulenes, some 9,468 acres from the slopes of Tamalpais to Tomales Bay, as a reward for halting Native American rebellions at the mission. The first Mexican land grantee on Point Reyes, Garcia moved to Olema, where he built a well-appointed adobe house for his large family. This sketch of the widely known patriarch Don Rafael was drawn by a Russian naturalist, I. G. Voznesenskii, on a visit to the rancho in about 1845. (Marin History Museum.)

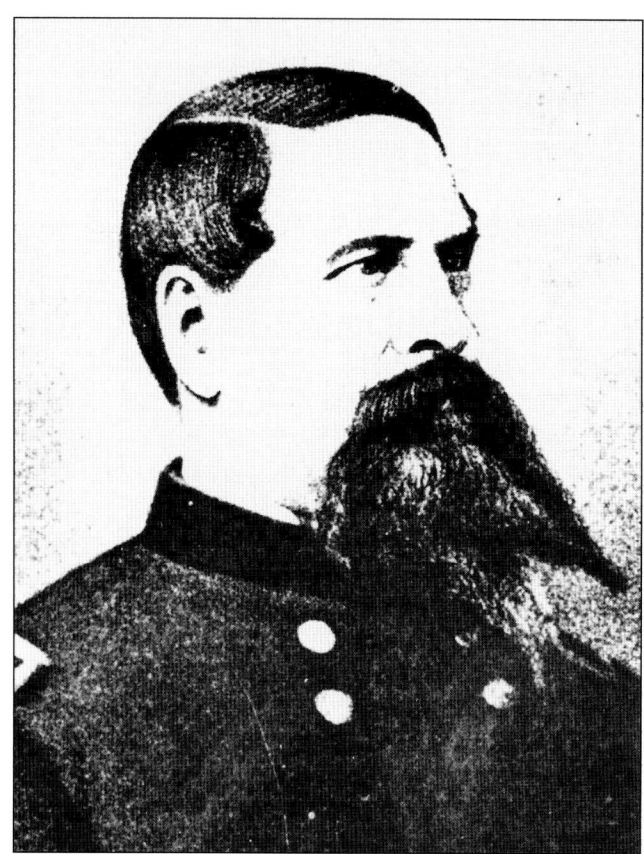

Joseph Warren Revere, shown here, was an American lieutenant stationed in Sonoma in 1846 when Don Rafael Garcia's rancho was in its heyday. Revere attended an unforgettable fiesta, including a feast, music, and dancing all night long. He later wrote, "The company regaled itself with unlimited champagne, and the delicate wines of the Rhine and Burgundy," scavenged from a local shipwreck.

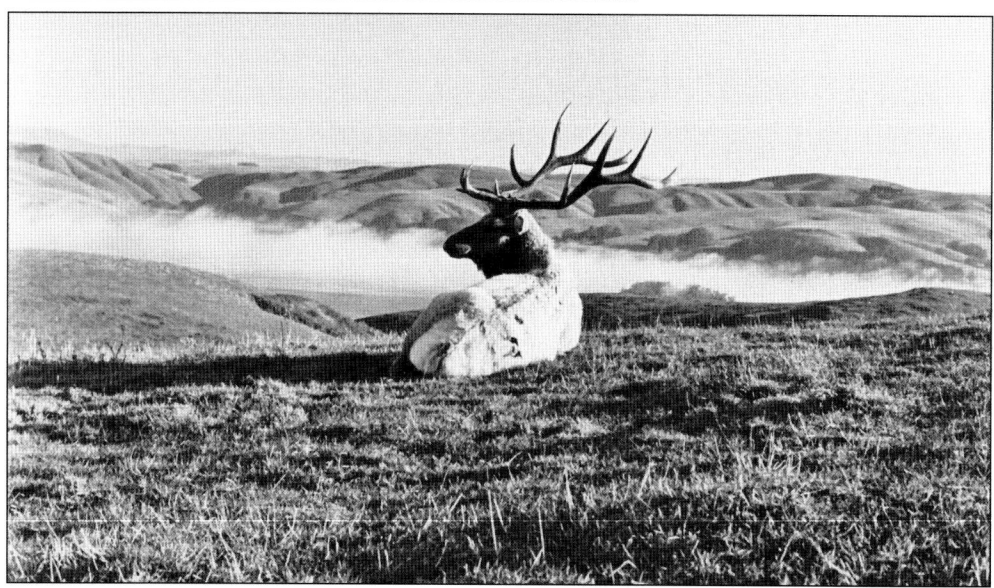

Revere accompanied an elk hunt, at which the American observed the fine techniques of the vaquero in action. The elk provided tallow and hides, as well as a fine fat, a local staple in cooking. Within several decades, the elk herds, over-hunted, would disappear entirely until being reintroduced on Tomales Point over 100 years later by the National Park Service. (PRNS Archives.)

In 1851, the U.S. Congress passed an "Act to Ascertain and Settle the Private Land Claims in the State of California." This map outlines the Point Reyes patents awarded after 17 years of litigation, during which time many of the Mexican land claimants went bankrupt over legal fees.

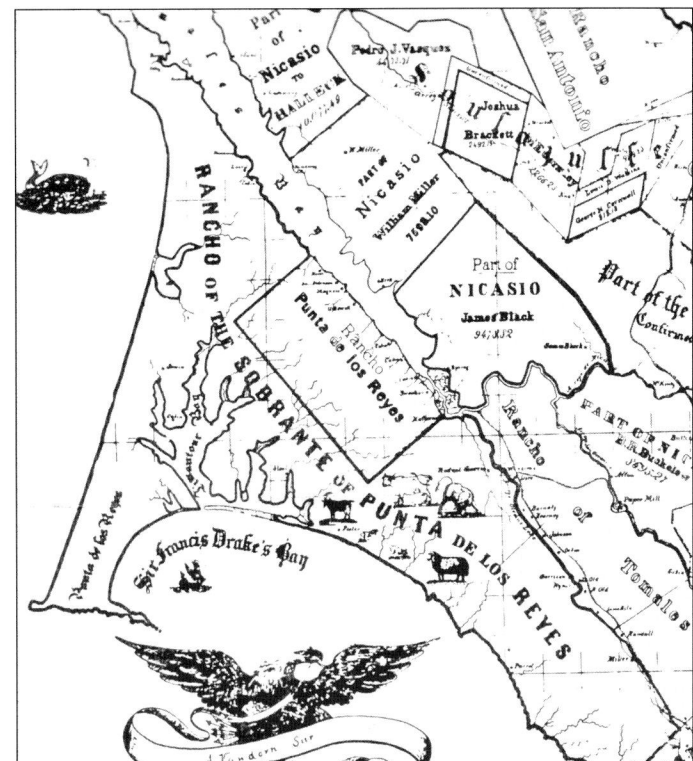

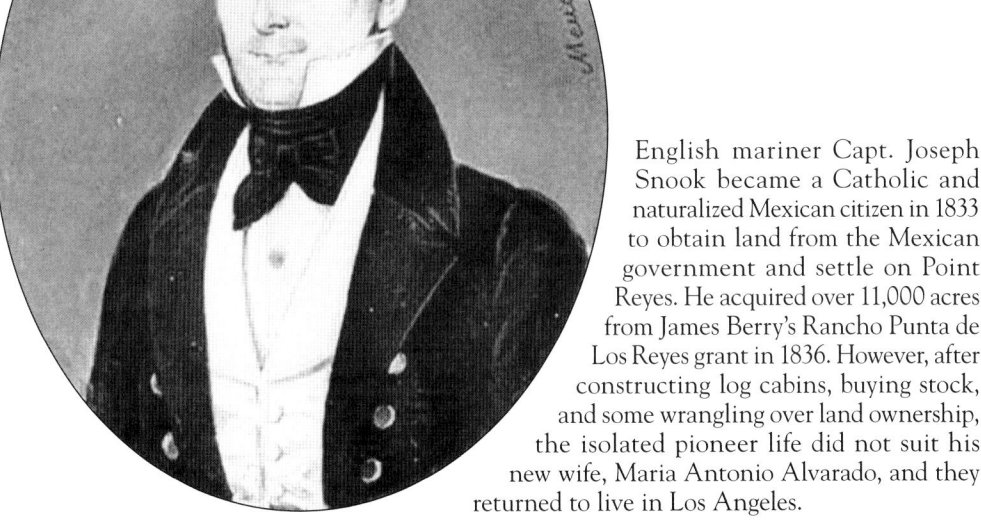

English mariner Capt. Joseph Snook became a Catholic and naturalized Mexican citizen in 1833 to obtain land from the Mexican government and settle on Point Reyes. He acquired over 11,000 acres from James Berry's Rancho Punta de Los Reyes grant in 1836. However, after constructing log cabins, buying stock, and some wrangling over land ownership, the isolated pioneer life did not suit his new wife, Maria Antonio Alvarado, and they returned to live in Los Angeles.

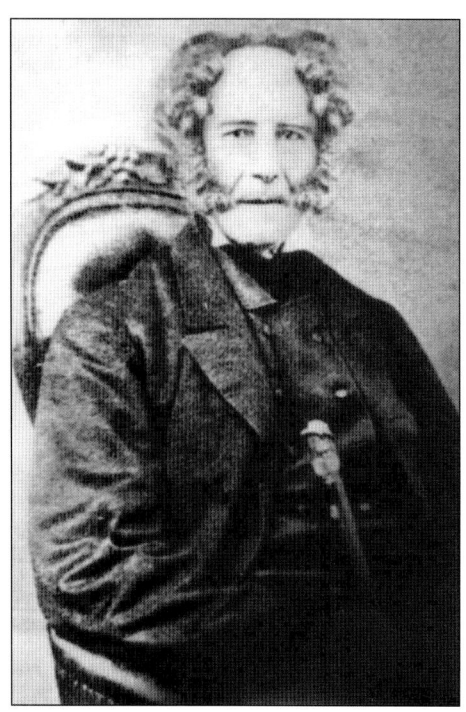

Antonio Osio, shown here, was a Monterey customs inspector and San Rafael judge. After he traded Captain Snook for his two leagues of Punta de los Reyes land, Osio was awarded 11 more leagues (48,829 acres) or *sobrante*, a vast majority of the Point Reyes peninsula. He sold part of his land to Andrew Randall in 1852 and moved his family to Baja, California.

Limantour Beach, Spit, and Estero were named for Joseph Yves Limantour (1812–1885), a French merchant who wrecked his 232-ton brig *Ayacucho* on the sand bar in October 1841. Limantour engaged in sea trade between Mexico and Alta California. He made claim to several million acres of California, including most of San Francisco, as a result of Mexican land grants. His claims were later judged to be fraudulent in federal court. (PRNS Archives.)

Two

Cow Heaven

The great California Gold Rush, which coincided with Point Reyes coming into American hands, led to a move toward exploitation of coastal resources. Men streamed into San Francisco and to the gold fields to the east, but many stayed behind or decided life in the rough-and-tumble mining camps wasn't for them. Marin County had little mining potential but did have copious redwood and luxuriant growth of native grasses—among the best to be found in the state. Dozens of forty-niners, as well as others looking for an opportunity, settled in the Point Reyes area with their sights on the green grass, which could be translated into rich feed for livestock. These newcomers dealt in the new California gold: butter and cheese. Out went the rangy longhorn cattle that had been butchered for their hides and fat, and in came fine Eastern and European dairy breeds. The early ranchers, most tenants of the brothers James and Oscar Shafter and a son-in-law, Charles Webb Howard, produced fine butter, which got top prices in San Francisco. Marin County was the leading dairy producer in California for much of the last half of the 19th century, and Point Reyes figured prominently. Growth in the state's dairy industry by the dawn of the 20th century left Point Reyes behind, but the region remained a major player and changed with the times. Sanitary milk production was the revolution of the 1920s, 1930s, and 1940s, and generations went by as families, most from Ireland, Switzerland, or the Portuguese Azores, made dairying their tradition. Today many of these same families milk cows in the same place their grandfathers did. Point Reyes families grew vegetables; raised chickens, pigs, and beef; and helped neighbors with haying and other ranch tasks. They played and hunted together, when time permitted, and attended school and church in remote places. The firm roots in Point Reyes soil is shown in the number of families remaining after five generations. Other industries soon appeared on the margins. In the 1920s, Italian and Japanese truck farmers established artichokes and peas, a healthy industry cut short by World War II. Some dairymen abandoned milking and raised beef, while fishing attracted European immigrants to Drakes Bay, Tomales Bay, and the Pacific Ocean. The clean estuaries provided growing grounds for oysters. Point Reyes is known for its breathtaking beauty, but its history of food production is unparalleled, even as suburban growth takes over nearby regions.

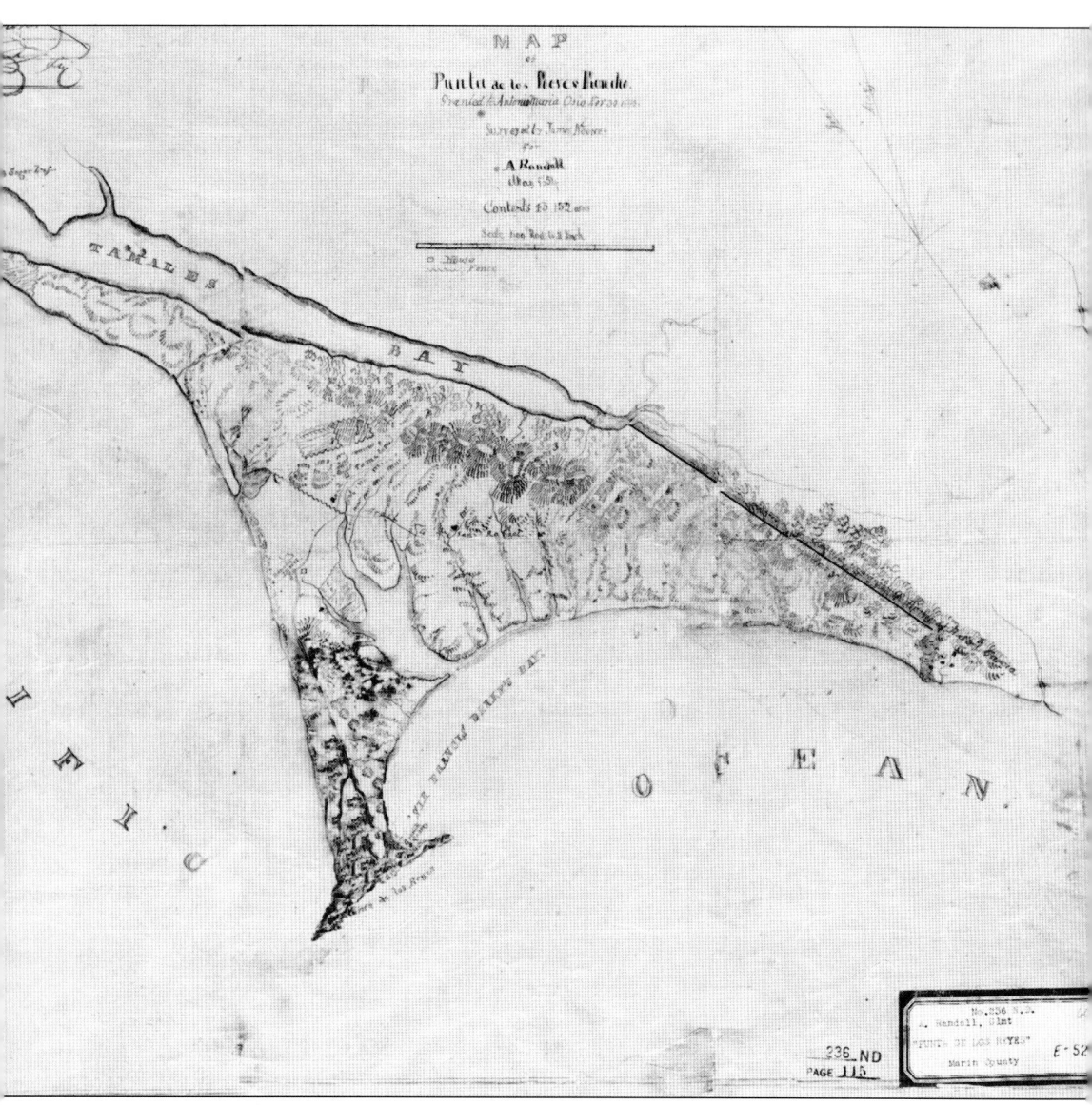

Following California statehood in 1850, land ownership on the Point Reyes Peninsula entered a period of contention as the old ranchos changed hands a number of times. Dr. Andrew Randall, founder of the California Academy of Sciences, bought almost the entire peninsula in 1852 using borrowed money. Randall's financial troubles led to his murder in the streets of San Francisco by a creditor (his assailant was hanged by a gang of vigilantes on those same streets) and the disposition of his properties ended up in court. The map above, made in 1854, was used in litigation over his debts. By 1857, no less than three parties claimed ownership of the peninsula, each having been fraudulently issued a deed by a corrupt local sheriff. (Bancroft Library.)

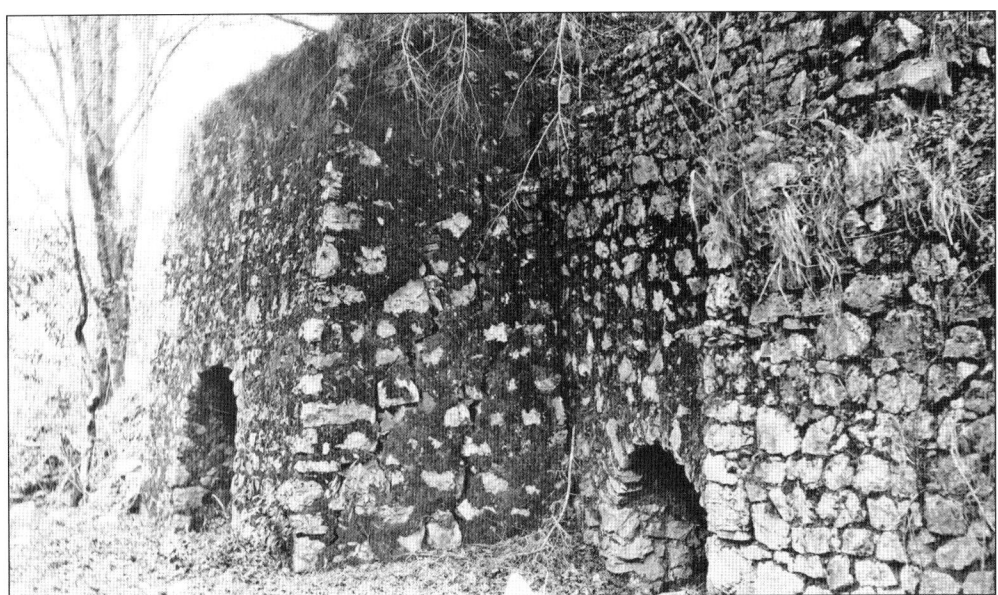

Early industries at Point Reyes included lime processing. Entrepreneurs constructed masonry kilns in a few locations in the Olema Valley, where nearby lime deposits were mined and "cooked" in the kilns, producing a raw material for cement. The only intact lime kiln, constructed in 1850 and rarely fired, is near Five Brooks.

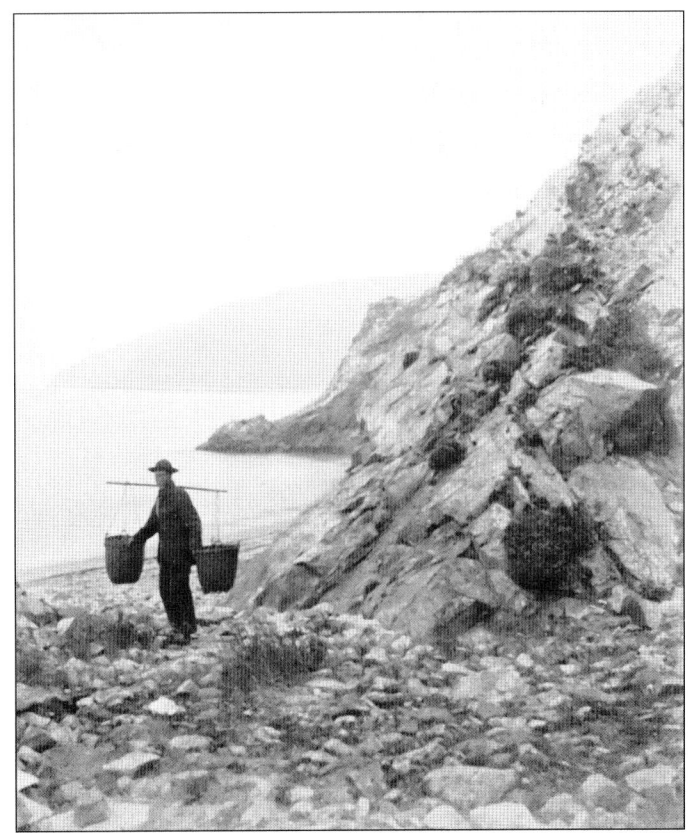

The waters and shores of Point Reyes provided food for the Coast Miwok and all who came after them. Otters were once plentiful in Drakes and Tomales Bays until their eradication by Russian and American fur hunters, while shellfish continued to be gathered by various individuals and commercial interests. This Eadweard Muybridge photograph shows a Chinese abalone gatherer at work in Drakes Bay around 1870. (Bancroft Library.)

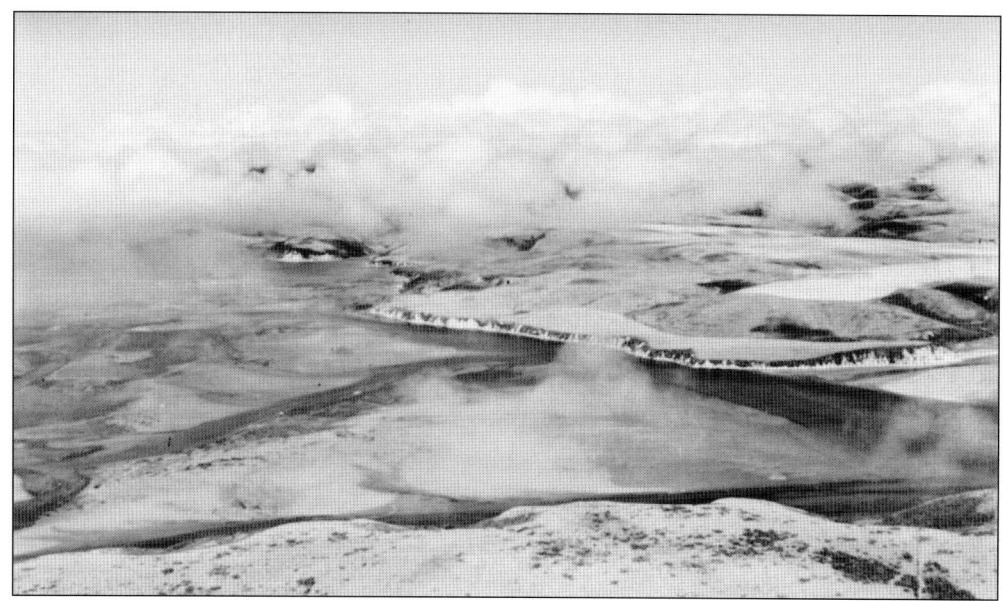

The salt air and summer fogs of Point Reyes (which Drake had referred to as "stinking fogges") produced rich native grasses that attracted livestock ranchers. The damp summers extended the green season, leading a pioneer dairyman to proclaim the place "cow heaven." Longer feeding periods allowed greater production, while the high-quality grasses resulted in superior cheeses and fresh butter. (PRNS Archives.)

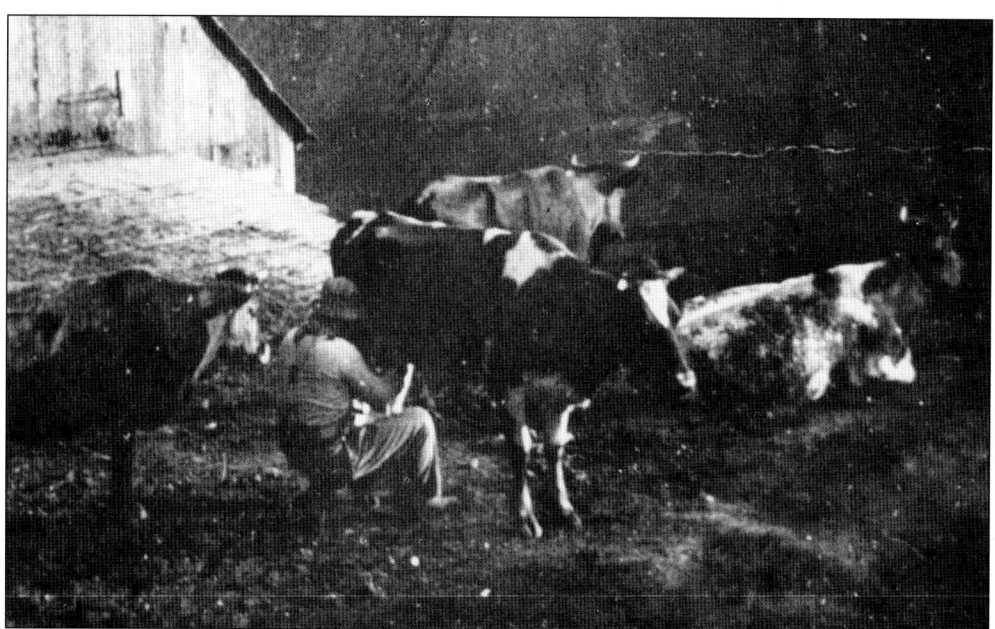

The Steele family is credited with establishing the first large, commercial, dairy ranch in California. The Steeles arrived at Point Reyes in 1857 and soon controlled 10,000 acres under a lease. Their butter and cheeses, produced on three ranches overlooking Limantour Estero, won awards and brought in a good income; soon dairies appeared on the peninsula in greater numbers. (PRNS Archives.)

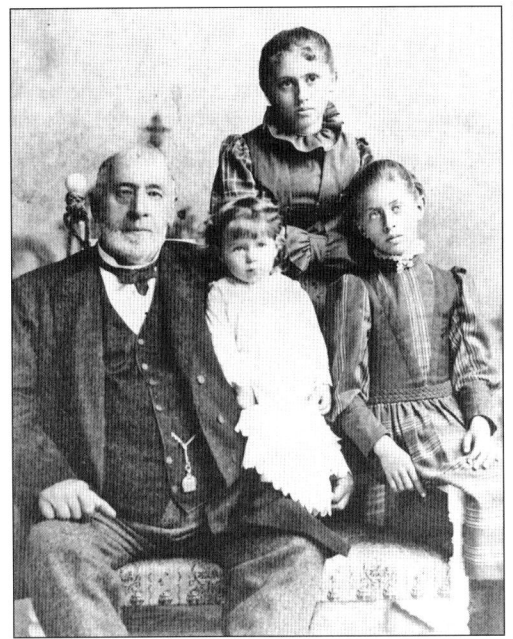

As the Steeles and their neighbors saw their first successes as dairy ranchers, a San Francisco law firm triumphed in court over ownership of Point Reyes. Shafter, Shafter, Park, and Heydenfeldt ended up owning the disputed lands. Partner James McMillan Shafter (left, with his granddaughters) took special interest in the dairying possibilities on their new property. Daughter Julia Shafter Hamilton (right) took over the family ranching affairs after her father's death in 1892.

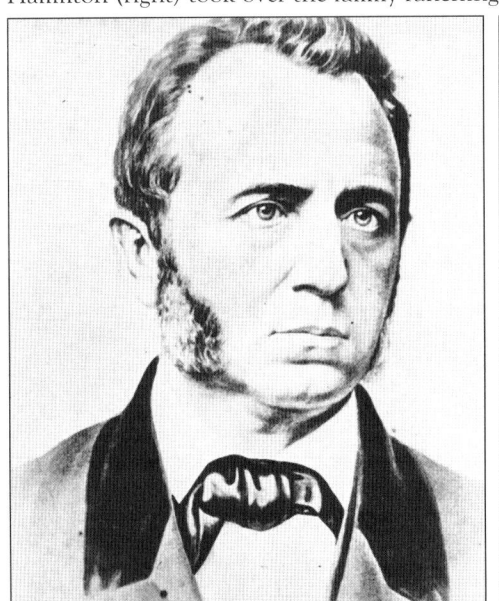 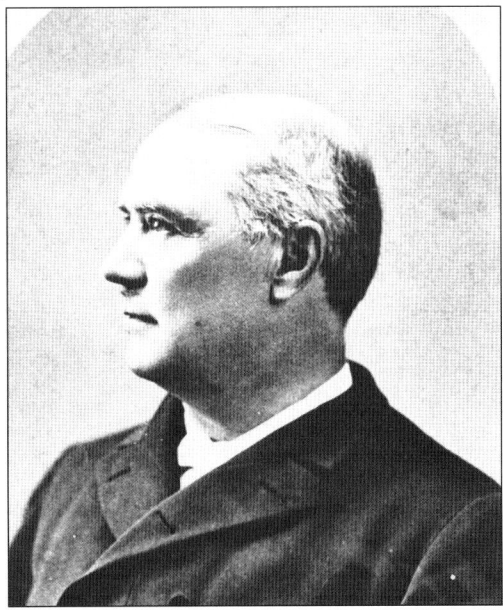

James and his brother Oscar L. Shafter (left) took over full ownership of the peninsula after buying out their partners in the law firm. Oscar Shafter brought in his son-in-law to help develop and manage the ranches. Charles Webb Howard (right), a prominent San Franciscan, had married Shafter's daughter Emma. By 1870, the Shafter brothers and Howard split their holdings into six sections, each owning two.

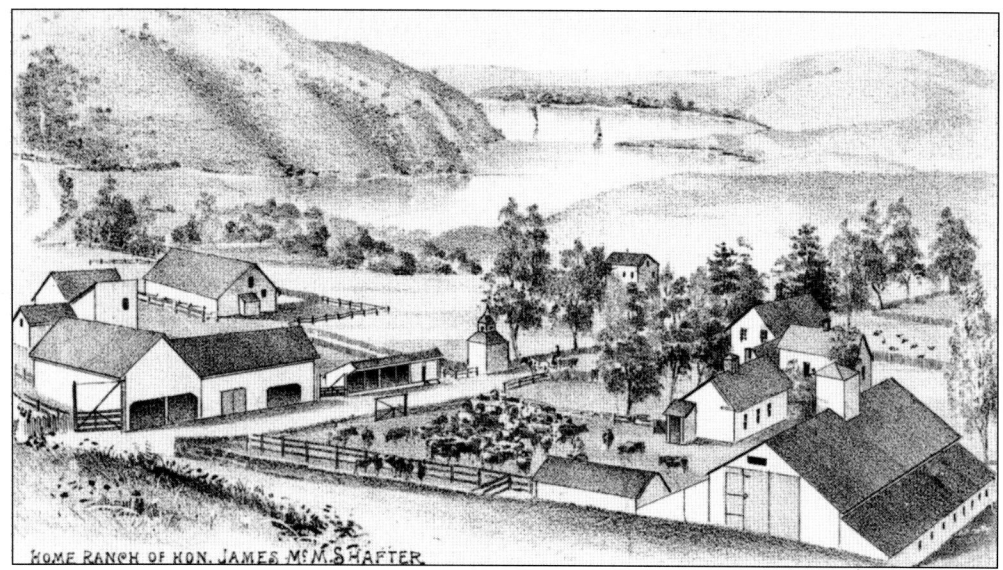

In 1858, the Shafter brothers constructed a headquarters at the center of the peninsula, known as the Shafter Home Ranch. Here their skilled managers developed processes for advanced breeding, butter-making, and sanitation that would produce the finest dairy products for post–Gold Rush San Francisco. The picturesque "village" remains today as an operating cattle ranch within Point Reyes National Seashore.

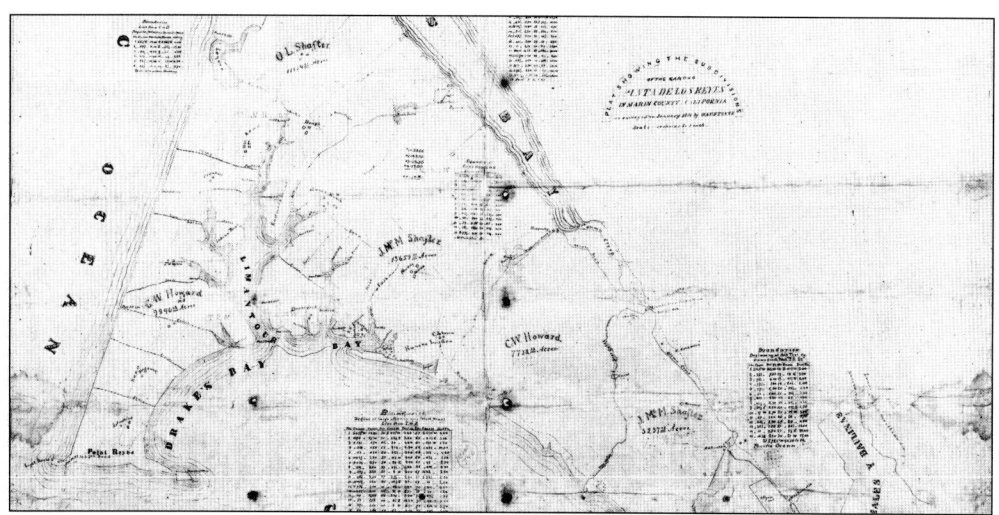

The Shafter brothers and C. W. Howard divided their property into more than 30 dairy ranches, each operated by a tenant. They labeled the ranches by letters of the alphabet, with A Ranch at the tip of Point Reyes and Z Ranch near the top of Mount Wittenberg, the highest peak on the peninsula. Depending on the availability of grazing and water, the ranches ranged from 400 to 1,200 acres in size.

Hinrik Claussen, a native of Sweden, supervised construction of the Shafter and Howard ranches. Claussen oversaw the erection of houses, creameries, barns, and sheds, all built almost identically. Dimensions of the house and barns depended on the size and potential productivity of the ranch.

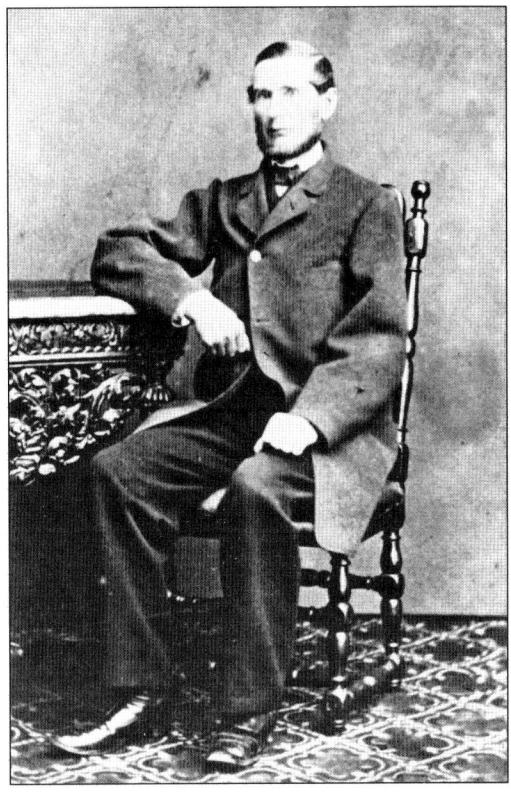

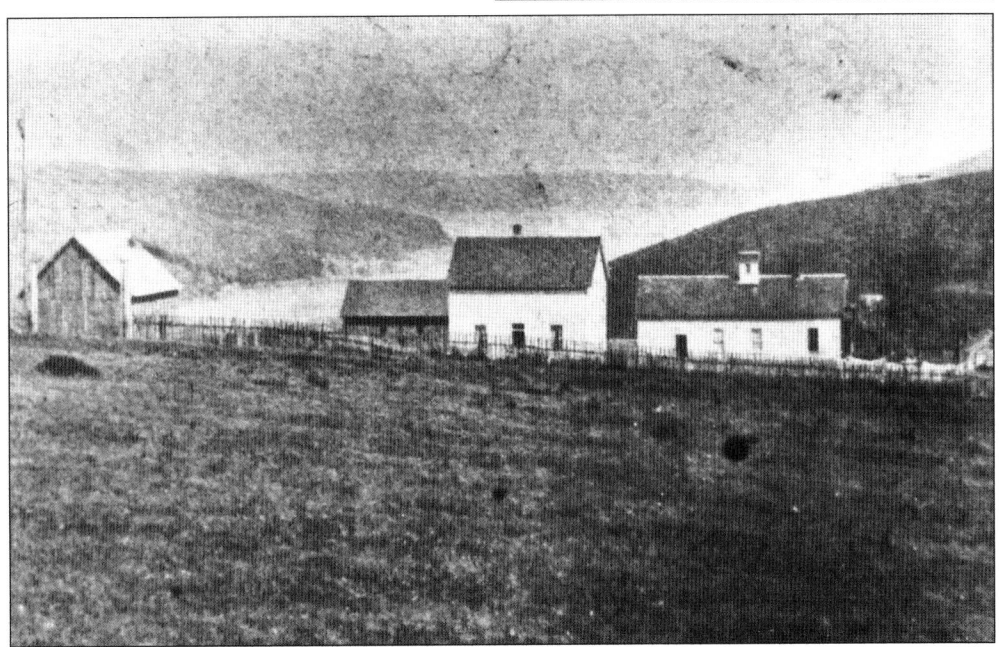

The E Ranch, overlooking Drakes Estero, started out as only a house, creamery, and sheds. As butter production increased, the landlords built a large milking barn and other amenities. The stark environment shows in this picture, taken before the tenants planted windbreaks as shelter from the unrelenting coastal winds.

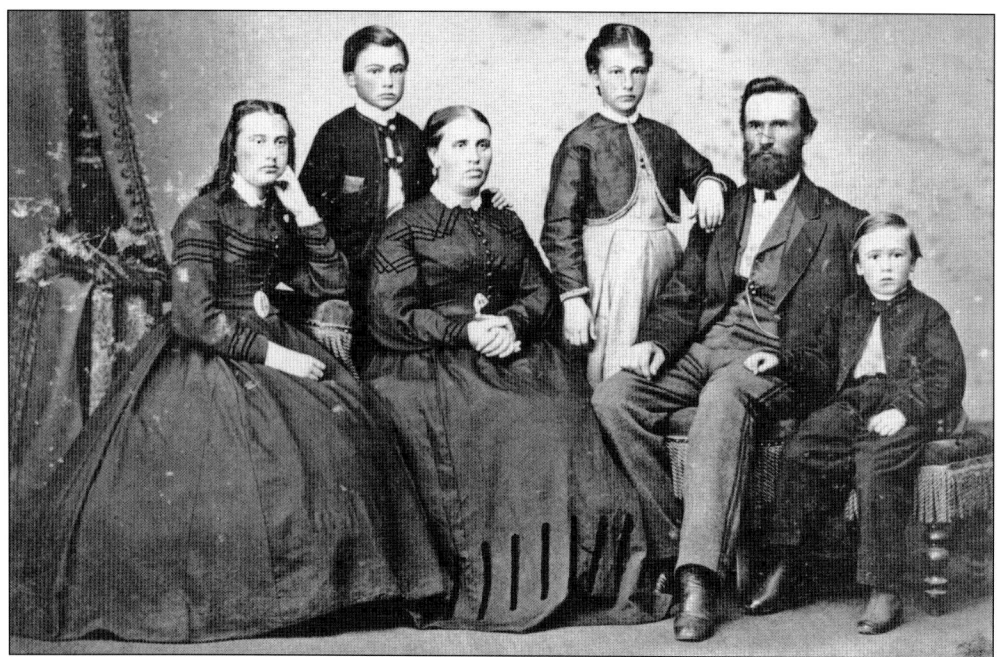

The Shafters and Howards sought tenants with skill and business acuity. Their first tenants were largely from the East Coast, many having come to California with the Gold Rush. The family of Carlisle Abbott (pictured above) settled at the H Ranch and thrived there before moving on to Salinas, where Abbott became a prominent citizen. Another tenant, Rufus Buell, moved south and founded the town of Buellton. (PRNS Archives.)

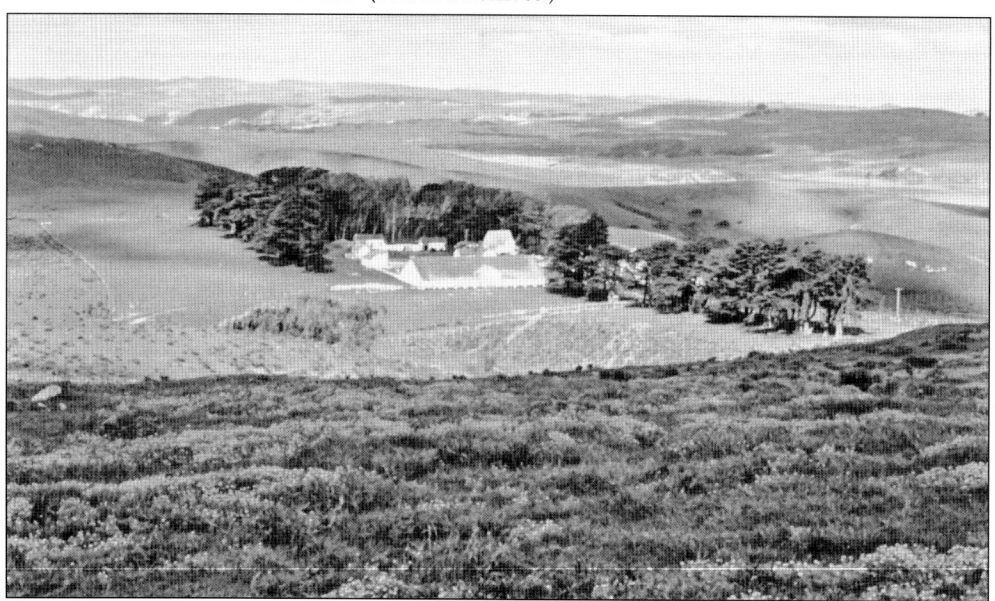

The Shafters' law firm sold only one major portion of their new lands, the 2,200-acre tip of Tomales Point, to a fellow Vermonter named Solomon Pierce. Here Pierce developed a premium dairy that may have surpassed the Shafters' in quality and fame. Pierce and his heirs built a beautiful New England–style farm complex, surrounded by trees and perhaps the finest pasture in the West. (PRNS Archives.)

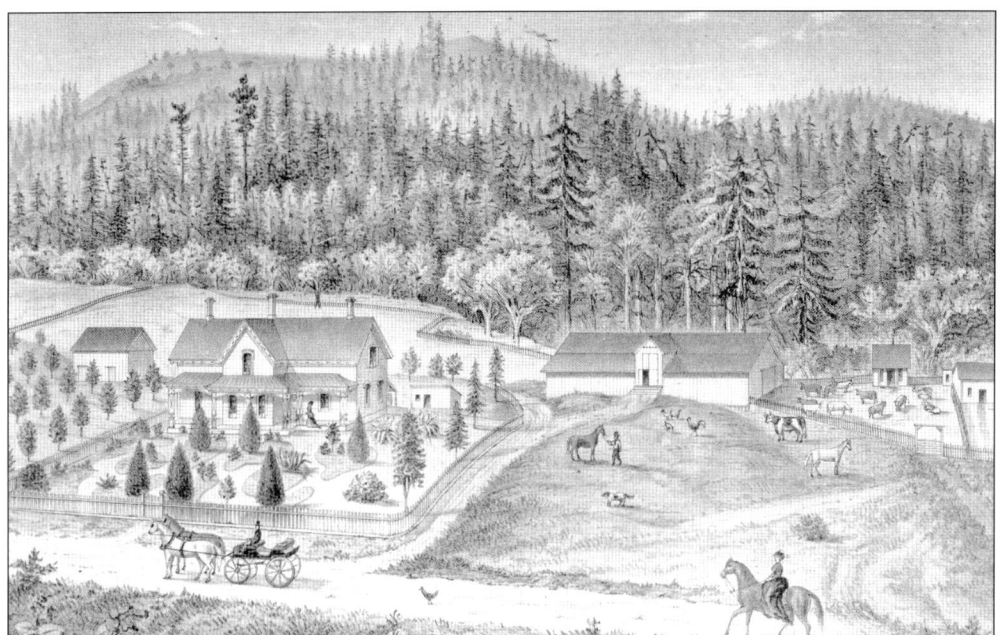

In the Olema Valley, an area not owned by the Shafters, Mexican grantee Rafael Garcia sold properties to individuals who developed ranches and farms in distinct styles, unlike the standardized tenant ranches of the point. Nelson Olds built his picturesque ranch that he called Woodside beginning in 1856, including a carpenter Gothic house and sophisticated landscaping. Since 1923, the Stewart family has ranched here. (Stewart family.)

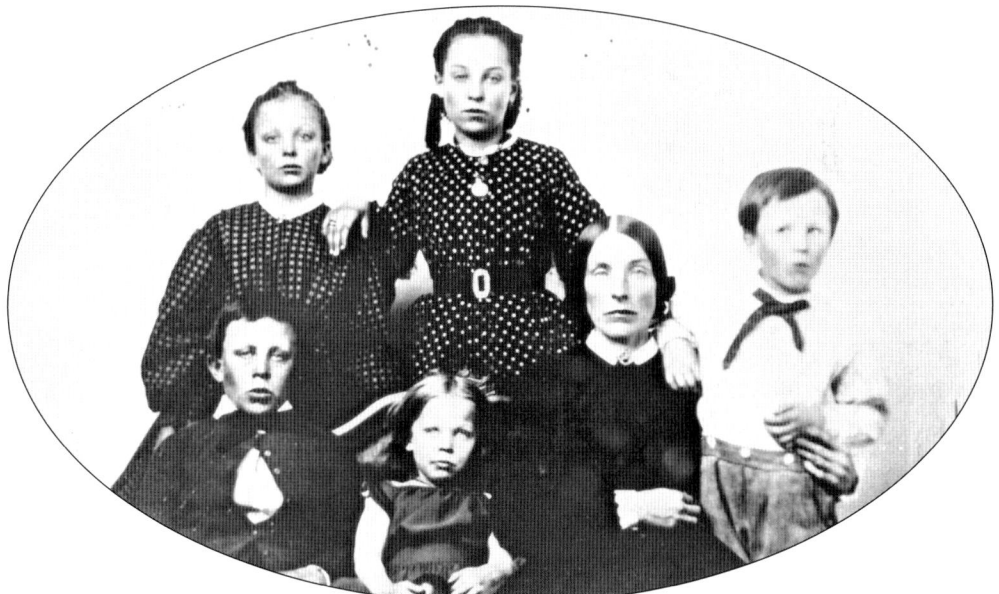

Andrew and Sarah Randall drove a herd of cows from Oregon's Willamette Valley in 1856 to start a dairy on lands bought from Garcia. A neighbor killed Randall in a dispute over a fence line, leaving his widow, Sarah, with five children (pictured in 1863) and a dairy ranch to run. Sarah took on the challenge, operating one of the prominent dairies in the area for decades. Her fine Victorian ranch house still stands halfway between Olema and Bolinas. (Bancroft Library.)

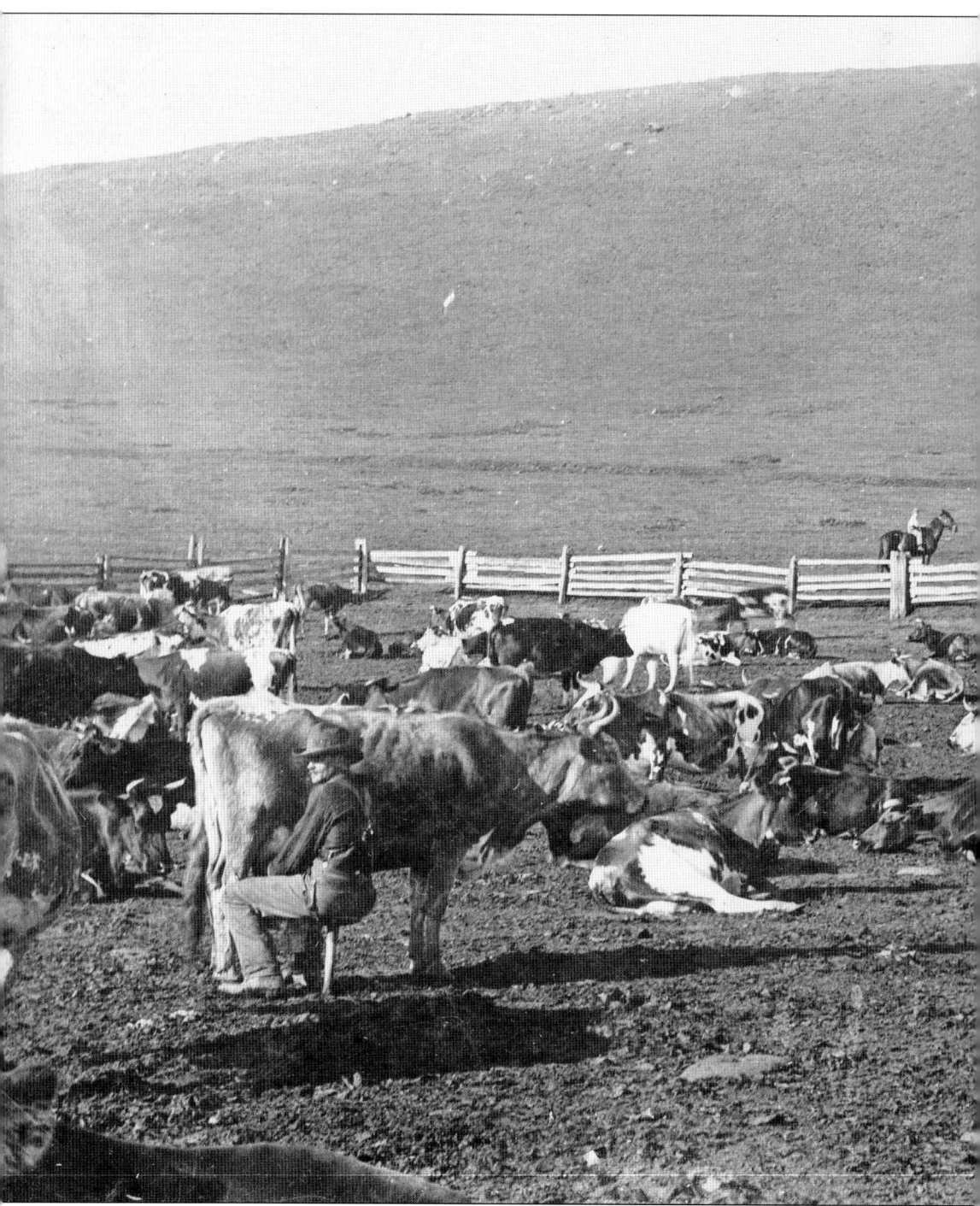

Cows have dominated the pastoral landscape at Point Reyes for over 150 years. Mexican grantees and early American owners ran longhorn cattle for their hides and fat, while dairy cows took over the pastures by 1858. Favorite breeds evolved over time from Devon and shorthorns, to Jersey and Guernsey, both high in butterfat. In good weather, hired hands milked cows outside, each taking on a "string" of about 25 cows. The faithful cows lined up for their favorite milker, who had a

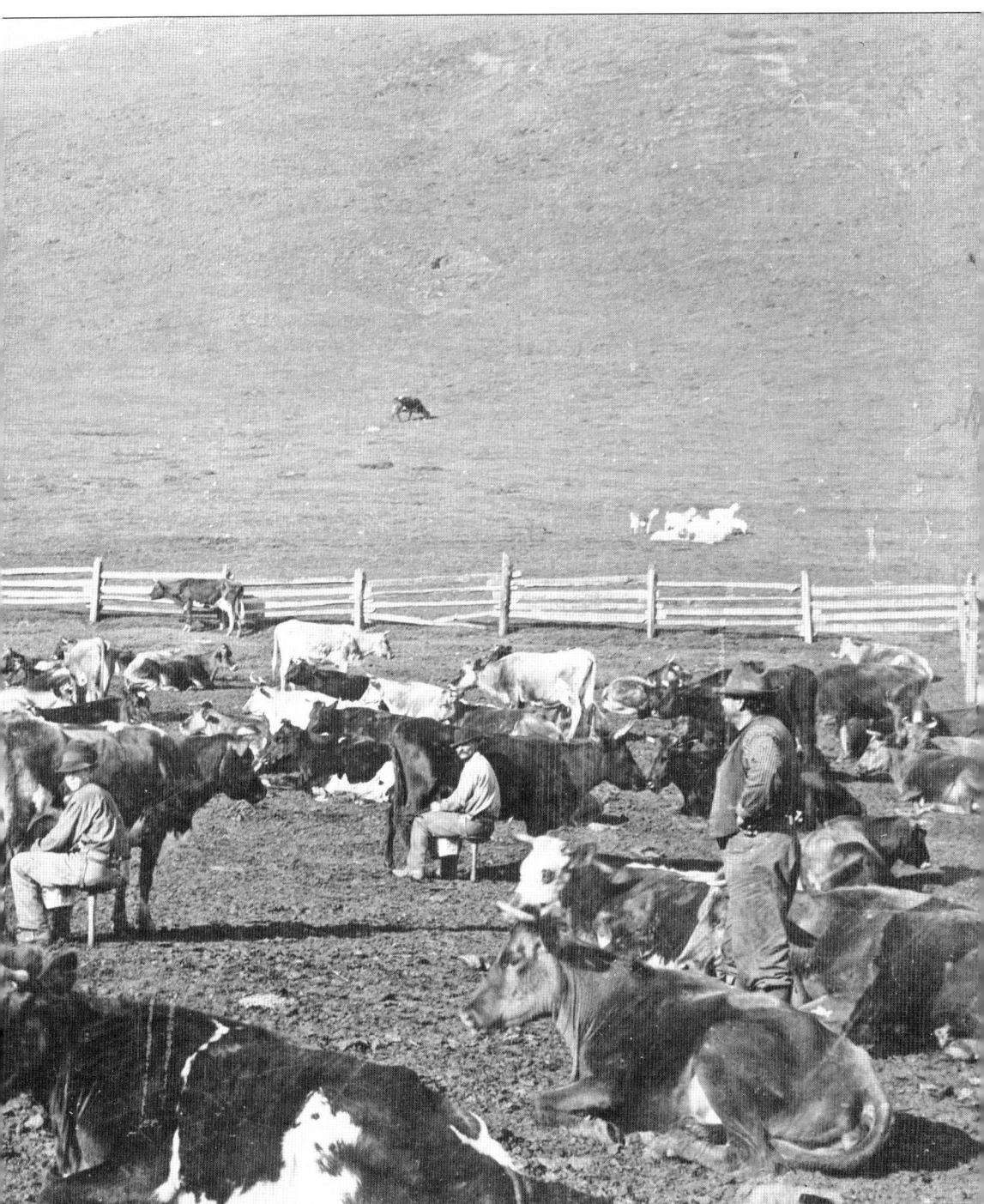

one-legged stool strapped to his behind. They carried the milk in buckets to the nearby dairy house, where it was strained and slowly separated in wide and shallow pans. The resulting cream was churned into butter by horsepower. For the last 50 years, Holsteins have been considered the ideal modern dairy breed. (PRNS Archives.)

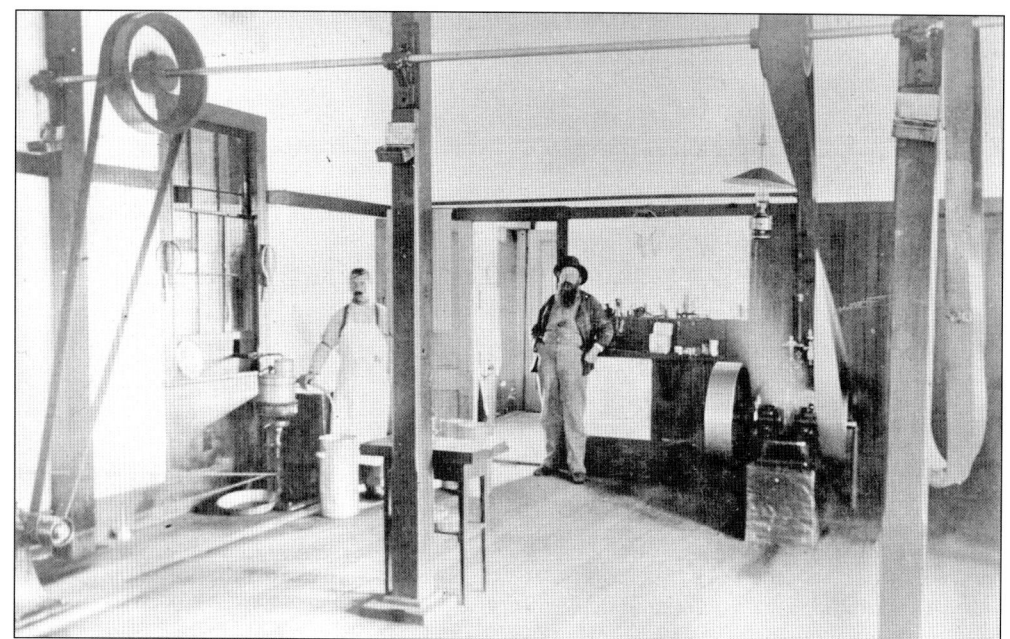

"Modern technology" of the 1880s brought the DeLaval separator, which skimmed off cream instantly. Ranchers fed the skim milk to pigs, which provided a supplemental income. This photograph shows the Claussen dairy at E Ranch, where Henry Claussen (right) and his butter maker John Paulino show off the separator, the steam engine, and the large churn (out of the picture on the right).

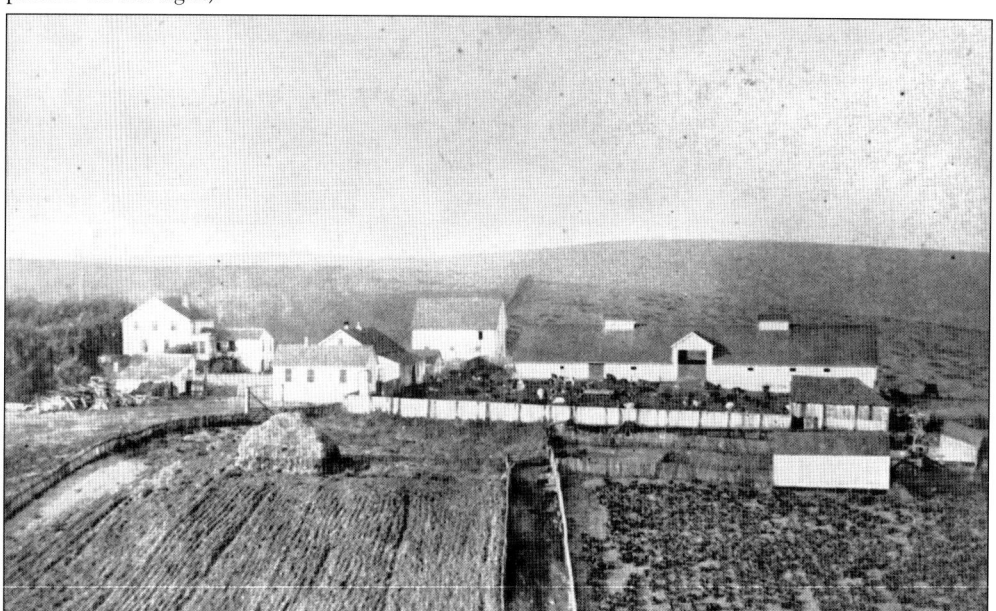

Henry Claussen, C. W. Howard's tenant and a son of ranch builder Hinrik Claussen, produced premium butter exclusively for the Palace Hotel in San Francisco on E Ranch. The ranch was nearly self-sufficient. The photograph shows, from left to right, the main house sheltered by a eucalyptus windbreak, the dairy house, calf shed, horse barn, and milking barn, with corrals and crops in the foreground.

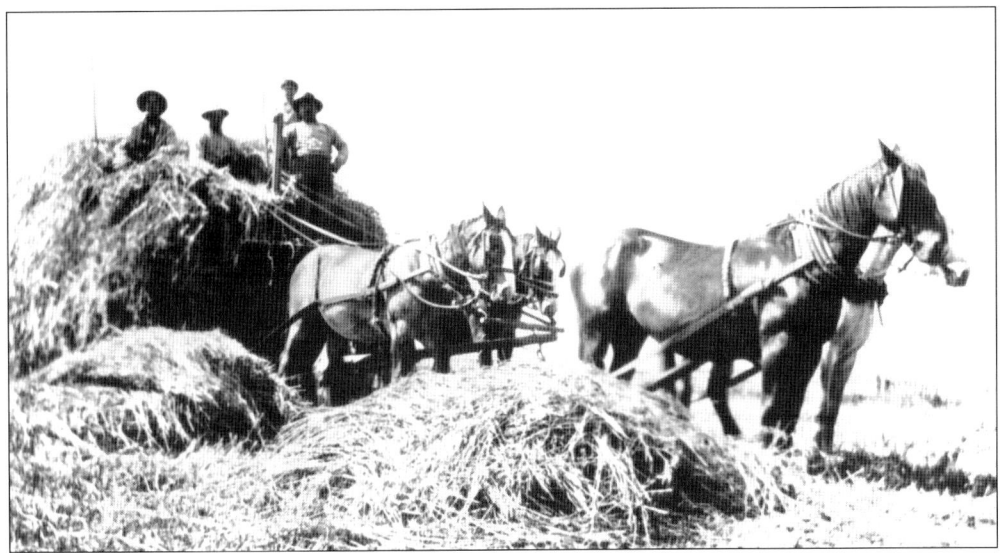

Point Reyes dairy ranchers grew feed for their cows on flat areas of the peninsula. Cows dried up in the summer and fall, giving the farmers time to tend to crops, fences, and other chores on the ranch. Haying time was a short period when neighbors came together to help bring in the crop, which was stored in haystacks and barns. (PRNS Archives.)

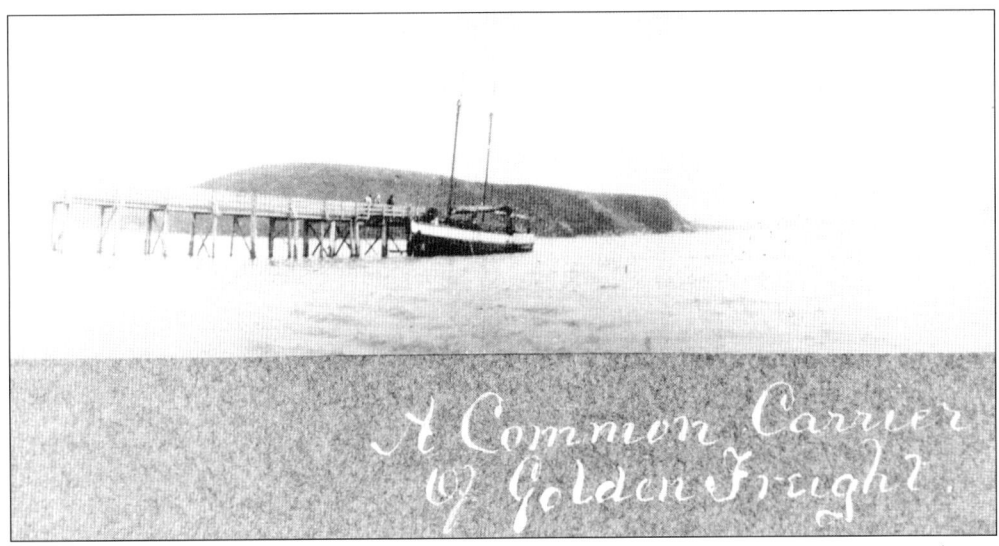

Point Reyes ranchers shipped their butter, beef, and pigs to San Francisco commission merchants on shallow-draft schooners, which entered Drakes and Limantour Esteros and Tomales Bay on scheduled stops to small piers and wharves. The tenants on ranches A through N shipped from this community pier in Schooner Bay. Many of these tenants eventually pooled their resources and bought their own schooner, the *Point Reyes*.

Ranchers closer to Tomales Bay sent their butter and pigs, beginning in 1875, across the bay on barges to meet the North Pacific Coast Railroad freights that ran down the east shore. The train and its connecting ferry delivered the products fresh to the Ferry Building in San Francisco. (Dan Brown collection.)

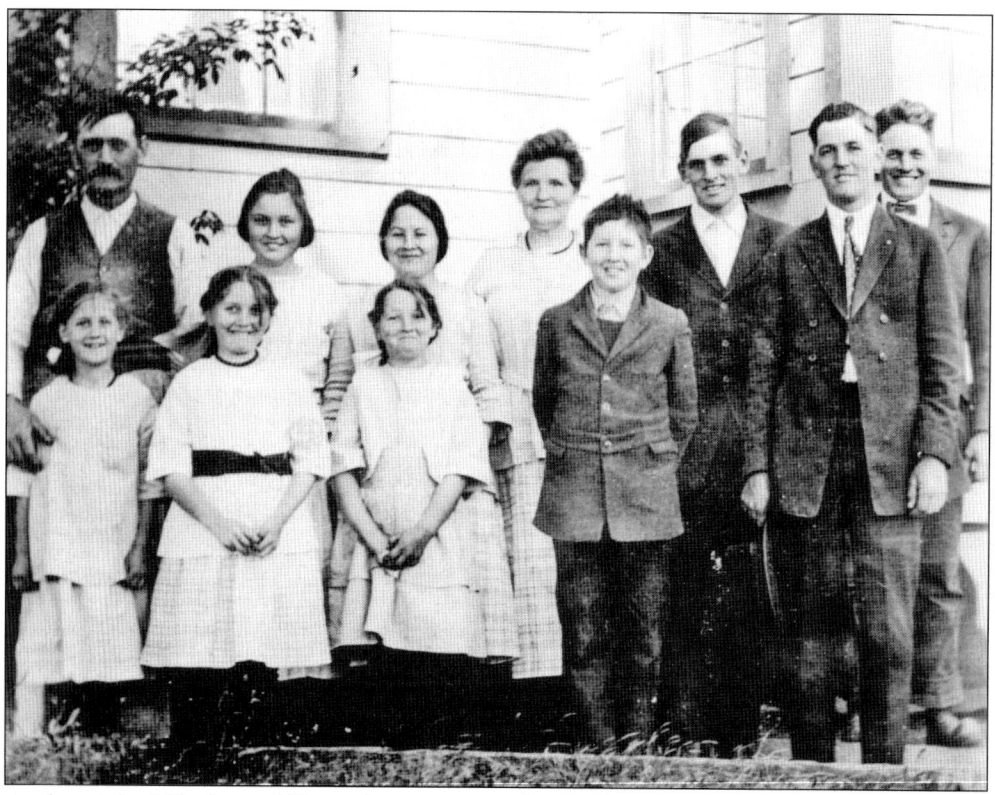

As the original Shafter and Howard tenants moved on in the 1860s and 1870s, immigrants from Ireland, southern Switzerland, and the Portuguese Azores took their places. The large family of Irishman James McClure posed on their porch in the early 1920s; McClure's great-grandson and his family still milk cows on the point. Other longtime families include Mendoza and Nunes (Azorean); Grossi, Spaletta, and Lucchesi (Swiss-Italian); and Gallagher, Kehoe, Lunny, and McDonald (Irish).

This woman tended to the household duties like doing laundry on the ranch, but women also participated in many of the traditional men's chores. Most took part in haying operations, and some even milked strings of cows. The traditional woman's role included tending to the children, gardening, cooking, cleaning, and feeding animals. (PRNS Archives.)

Azoreans on Point Reyes built an Irmandade do Divino Espirito Santo (Brotherhood of the Divine Spirit) "Holy Ghost" Hall on the road to the lighthouse, which was used for religious festivals and parties. Other uses included school board meetings, voting, and dances. Some parties went for the whole weekend, with the men going home to milk their cows and then returning for more dancing.

37

The center of commerce at isolated Point Reyes was the post office at F Ranch. Not to be confused with Point Reyes Station, the railroad town located 10 miles east, the Point Reyes Post Office acted as a gathering spot. The road to the schooner landing took off from here, and anyone heading to the lighthouse passed through. The post office moved to D Ranch in 1920. (Postmark, Dan Brown collection.)

The Point Reyes District School, on the M Ranch, served all the children of the point except for those at Pierce Point and south of Muddy Hollow. When the sizeable McClure family temporarily left Point Reyes around 1920, the school closed for lack of students. Joseph Mendoza of the A and B Ranches hired his own teacher and opened a new school in a shed on his ranch near the lighthouse. (PRNS Archives.)

Point Reyes ranchers worked hard under harsh circumstances. When they had a chance, families set off on picnics with neighbors and visitors. Members of the Claussen family posed at a grassy meadow somewhere on the point. (PRNS Archives.)

Ranchers occasionally took breaks to play baseball, visit with neighbors, or spar with friends. These guys at Home Ranch look to be readying for the championships. (PRNS Archives.)

Hunting was a way of life, with plentiful game on the ground and in the air. Migrating ducks and geese, pheasants, wild turkey, and others came down with the blast of a shotgun, while deer (the elk and bears had long fled the area) fell to the rifle. Ranchers and city men took their vacations in the nearby hills and formed hunting clubs that gave them wider access to local lands.

Federico ("Fred") Genazzi, a native of Switzerland, played songs from the old country. The Point Reyes area changed with the times, and the 20th century marked the passing of many of the original immigrants. Their sons and daughters took on American ways, including names, and worked to modernize their dairy ranches. Some left for other occupations in town or took on larger dairy ranches in the central valley.

A major change in the dairy industry came with the sanitation laws of the early 20th century, which ended butter-making on the ranches. John Rapp's Bear Valley Dairy began shipping certified milk to San Francisco hospitals in the early 1920s, the first in Point Reyes to do so. The state-of-the-art dairy farm took special care in sanitation and processing, and delivered fresh bottled milk and cream in their own trucks. The dairy continued production under the ownership of Jesse Langdon and is today the administrative headquarters of Point Reyes National Seashore. (Above, PRNS Archives; right, Dan Brown collection.)

Milking machines made the job of a rancher easier. Alfred Grossi showed off his portable milking machine in his barn at the H Ranch. He would carry the sealed bucket to the milk tank after every cow. Eventually, the milk was transported directly from udder to storage tank, offering the highest level of sanitation and safety. (PRNS Archives.)

Tractors revolutionized life on the farms of America. Local ranchers could grow more feed for their herds and no longer had to tend workhorses. By the late 1940s, feed and transportation was cheap, so local ranches stopped growing feed crops and set their fields back to pasture. Today ranchers are again growing feed on the ranch.

In the 1920s, a group of Italian farmers rented former grazing land on Limantour Estero from the Shafter family on which to grow artichokes. The truck farms grew to include peas and other vegetables, all trucked to San Francisco. While the Italians grew artichokes, Japanese immigrants tended the pea crops on separate fields. These farms were located on the Murphy Ranch and B, F, H, and N Ranches. (California Historical Society.)

This rare photograph shows a picnic gathering of Italian and Japanese farmers on Limantour Beach in the 1930s. Both groups were newcomers and were often treated as second-class citizens. After Pearl Harbor, the Japanese families were interned, and the Italians were restricted from approaching the coast. For the most part, their rented lands returned to grazing. (PRNS Archives.)

Farming returned after the war, but it never returned to its prewar importance. Leland Murphy rented his fields for pea crops destined for the frozen market. The photograph shows members of the Gomez family from Mexico harvesting peas on the Murphy Ranch. The last peas were grown in the early 1950s. Italian artichoke farmers Jim Colli and Allesandro Simondi continued with their farms nearby. (Lee Murphy.)

Cattle rancher Robert Marshall rented acreage on his Laguna Ranch to a San Francisco flower marketing business during the 1950s. The bottomlands of his cattle ranch bloomed with tiger lilies, daffodils, and other decorative flowers. Today daffodils bloom in the spring, leftover remnants of this once-flourishing West Marin business. (Marin History Museum.)

Commercial fishing on Drakes Bay and Tomales Bay grew in the early 20th century as Italian-owned fish merchants from Fisherman's Wharf in San Francisco established shipping docks at Point Reyes. On Tomales Bay, a number of coves were inhabited by families of Slavic fishermen who plied the waters for seasonal fish that were sent to market on the train. (Patricia Clark collection.)

Oystering became an important business in Tomales Bay as early as 1875. Drakes Estero was planted with oysters in the 1930s, and the business there flourished, producing the majority of local oysters. The photograph shows employees of Larry Jensen collecting the bivalves on mudflats in 1950; his successor, Charlie Johnson, brought the less destructive, Japanese method of hanging racks to the area. (M. Woodbridge Williams.)

Some dairy ranches converted to raising beef cattle in the 1940s and 1950s. A beef ranch is less labor intensive than dairying; a base herd of mother cows gave birth to calves, which were raised in the pasture and sold to feedlots for fattening. Today some Point Reyes ranchers are raising grass-fed cattle, considered to be a healthy alternative to conventional beef.

Frank Truttman (left) and Armin Truttman check on their milking herd in Olema in the 1960s. Scientific advancements in the dairy industry brought improved breeding and ranch practices, which in turn provided more milk and insured the consistency of the product. Today's dairy cows are monitored with computers, which track feed inputs, health, and milk production. (Marin History Museum.)

Three

Wayfaring by Sea and Land

Point Reyes Peninsula has a close relationship with water: it is practically surrounded by the Pacific Ocean and Tomales Bay. It is also remote, despite the relatively short distance to San Francisco. Early settlers relied on the water to get to and from San Francisco, and the little, agile butter schooners flitted up and down the coast like jitneys. If the local residents had the patience (or were susceptible to seasickness), they took the long and rough overland route to the city, which still required crossing San Francisco Bay on a boat. The emerging, and soon booming, coastal lumber trade brought hundreds of laden ships passing Point Reyes—rather, carefully avoiding Point Reyes. The rocky protrusion of the point and the treacherous beaches with dangerous surf and undertow caused the mariners to take special care while in the area; nonetheless, many were unfortunate and wrecked. The dangers to commerce resulted in government intervention in the form of a fine lighthouse and a well-staffed lifesaving station. Life at these bleak outposts, covered in fog for weeks on end in the winter and summer, could be as risky to the soul as the surf to a ship's captain. The government crews were later joined by private wireless radio stations, which transmitted and received messages by Morse code from the farthest reaches of the Pacific. Famous names of the communications industry's past like Marconi and RCA settled on the Point Reyes Peninsula, finding the perfect atmosphere for receiving signals from long distances. An alternative to maritime shipping came in 1875 with the North Pacific Coast Railroad, partially funded by one of the Point Reyes landowners, which laid its tracks out to Tomales Bay and north to the redwood country. Now dairy ranchers could ship butter and cream more efficiently and visit folks farther away. The narrow-gauge train remained in operation until 1933, by which time another invention had shaken the world. The automobile changed everything. Now the family could travel to town quickly (if it weren't for all those gates!), and soon the cry for good roads reverberated in West Marin's hills. Pavement reached the area by 1930 in the form of a fine concrete roadway dubbed, with a nod to local history, Sir Francis Drake Highway. The trip to "the city" took an hour, and that worked the other way around: along with the locals and produce trucks came sightseers and prospective residents.

In 1910, a group of Point Reyes dairy ranchers collectively purchased a gasoline schooner, which they christened the *Point Reyes*. This fast and modern boat reliably served the route between Schooner Landing and San Francisco well into the 1920s. Later she was put into the service of rumrunners.

The Point Reyes schooners carried butter and pigs but also people. Residents of the isolated area occasionally traveled to San Francisco aboard one of the sailing or power schooners, relying on a trusted captain such as John Low, at left.

48

Heavy fogs, dangerous surf, and the jutting and rocky Point Reyes headland itself posed hazards for the coastal sea captains during the 19th century. Dozens of ships went aground at Point Reyes, often in a dramatic fashion, while few lives were lost. The coastal steamer *Samoa* went aground at Ten-Mile Beach in 1913, prompting a dramatic rescue by men at the nearby lifesaving station. The wreck drew curious visitors for many days until the ship broke up; the bow of the ship made an interesting landmark for many years before disappearing into the sand. (PRNS Archives.)

As soon as California became a state, federal officials looked to Point Reyes as a site for a lighthouse. This 1852 survey was the first to locate a light tower, fog signal, and keeper's dwelling on the very tip of Point Reyes. A combination of bureaucracy, isolation, and haggles with the landowners delayed construction until 1870. Engineers cut a road from Drakes Bay to supply the construction site, which posed many hazards as crews cut stairs and large benches in the sheer cliffs to accommodate the station. (PRNS Archives.)

The handsome yet functional light tower was constructed of iron plates bolted and riveted together, all secured into the solid rock and concrete foundation 273 feet above the crashing surf. Inside the delicate-looking lantern room, an intricately assembled Fresnel lens was mounted on a meticulously balanced circular track. The entire first-order lens and lamp assembly turned at a carefully geared pace to produce a flash every five seconds. Famed pioneer photographer Eadweard Muybridge took this photograph of the newly constructed lighthouse in 1870 or 1871. (Bancroft Library.)

In addition to a lighthouse, engineers constructed a steam-powered fog signal on a precarious bench 100 feet below the light tower. The frequent coastal fogs obscured the light from passing mariners at times, so the fog signal alerted ships of their location with a powerful whistle blast, later replaced with a siren. The fog signal required huge quantities of water and coal, and was eventually modernized and moved up to a ledge next to the light tower. (Bancroft Library.)

Access to the light tower and fog signal was provided by a series of stairways consisting of 638 wooden steps. A railing helped keepers steady themselves during frequent heavy winds, while a tramway allowed the transport of supplies up and down. The stairs were later replaced with concrete and shortened, with the number of steps reduced to 304. (Ralph Shanks collection.)

The keepers of the Point Reyes Light Station led lives of challenge: the weather was often dreadful, the location was lonely, and the work was time-consuming and repetitive. Keeping watch was usually a boring task. The complex and delicate French-made Fresnel lens needed constant care and cleaning because the lamp oils clouded the glass from the inside and the ocean air left films of salt on the outside. The intricate clockworks, the real guts of the lighthouse, had to be tended like a fine Swiss watch in order to keep the flashes consistent. Other tasks for the keepers included tending the wicks and fuel supply, calibrating instruments, keeping the fog signal going when needed, painting, repairs, and record-keeping. (PRNS Archives.)

Keepers of the Point Reyes lighthouse lived in this house and another not pictured. The U.S. Lighthouse Service provided quarters like this at all stations on the coast. This building acted as a home, office, gathering place for neighbors, and shelter from storms. It was torn down and replaced in 1960 by the U.S. Coast Guard. (PRNS Archives.)

The keeper wrote meticulous logs of daily activities at the light station. Keepers traveled to headquarters in San Francisco (usually transported on a ship called a tender, which delivered supplies) and took leave in nearby towns. Eventually, the U.S. Weather Bureau established a weather station at the light station, relieving the keeper of some of his record-keeping duties.

Point Reyes was a tough assignment, and many keepers came and went. After years of personnel problems, including drunkenness and desertion, the lighthouse service encouraged keepers with families to staff the station. By the start of the 20th century, children were a part of lighthouse life. Baby Robert Smith was born and raised here; in this photograph, his wicker carriage is perched at the edge of a high cliff.

Joseph V. Mendoza established a school on his ranch near the lighthouse in 1921, providing a teacher for children of the keepers. When the new coast guard lifeboat station opened nearby in 1927, enrollment increased. These local kids are posing at the light station. (PRNS Archives.)

55

The windswept Point Reyes lighthouse has been a popular destination for adventurous travelers since it opened in 1870. By schooner, by wagon, and eventually by automobile, people enjoyed the rugged scenery, endless ocean view, passing whales, and the wonder of the lighthouse itself. Visitors included novelist Jack London and his wife on June 6, 1911, seen on the 13th line in the visitor log. (PRNS Archives.)

While the Point Reyes lighthouse and fog signal offered guidance and a sense of safety to passing ships, hazards and wrecks continued. In 1890, the U.S. Life-Saving Service established a station on Ten-Mile Beach in full view of the churning Pacific Ocean. The stylish quarters and boathouse were built on the sand dunes and were occupied until 1927.

The Point Reyes Life-Saving Station was manned by six to eight "surfmen" and a keeper. Their well-equipped government boathouse featured the latest in lifesaving apparatus, including a "lifecar" hanging in the upper right, which could be pulled through the surf with shipwreck victims safe inside.

57

The keeper at the Point Reyes Life-Saving Station, like Hans Olsen (pictured at left), had tremendous responsibilities: he maintained discipline through long and tedious days (since shipwrecks were few), ran dangerous drills, and kept his crew of surfmen on the ready at all times. The loneliness of the station and the dangers of the location posed problems for keepers, and his surfmen often expressed frustration. In one case, the entire crew resigned and the keeper was charged with cruelty. The crew's only communication with the outside world was through the mail, with a post office five miles away on a sandy road. Surfman Sven Hansen posted this letter at the Point Reyes Post Office on F Ranch. (Left, Kathy Meier; below, Dan Brown collection.)

The beach cart contained all the necessities for accomplishing a rescue from the shore, including a Lyle gun that would shoot a line to a ship. Most of the early surfmen at Point Reyes were of Scandinavian descent. Their days were filled with drills, beach patrols, maintenance, and study. They filled their time off with music, games, and local travel. Below, it appears that a surfman has been married, as his fellow crew used the beach cart, normally laden with lifesaving equipment, as transportation for the newlyweds. (Both, PRNS Archives.)

The most dangerous practice drill at the Point Reyes Life-Saving Station involved hauling a lifeboat to the shore and launching it into the surf. At many stations across the country, this was a routine and safe activity, but at Point Reyes, the heavy surf and undertow made it a deadly practice. At least three men lost their lives during drills at the station and were buried at a small cemetery on the G Ranch. Coast guard and National Park Service volunteers maintain the site today. The dangers of the station led the government to construct an auxiliary boathouse on Drakes Bay at which the men could drill in safety. (Both, PRNS Archives.)

One of the most spectacular rescues involved the *Samoa*, a steam schooner laden with lumber, which went aground nearly in front of the lifesaving station in 1913. Surfmen quickly approached the wreck with their beach cart, shot a line to the ship with a Lyle gun, and set up a breeches buoy with which to haul victims to shore, one by one. Only one life was lost in this famous rescue.

The U.S. Coast Guard superseded the U.S. Life-Saving Service in 1915, and in 1927, an entirely new Point Reyes Lifeboat Station was built at a sheltered spot in Drakes Bay. The handsome boathouse and barracks building were constructed on pilings and featured a marine railway from which heavier, motor-driven lifeboats could be launched. (PRNS Archives.)

61

Coast guard brass posed with the station cook on the marine railway at Point Reyes. (Al Clarke collection.)

This aerial view shows the entire Point Reyes Lifeboat Station and the neighboring commercial fish docks. At the bottom is the boathouse, and in the trees near the center are the officer-in-charge's house and auxiliary buildings. A radio tower, surrounded by a circular fence, is at the far left, and the barge in the foreground is the U.S. Navy paint test barge, on which marine paints were tested. The Point Reyes Lifeboat Station is a National Historic Landmark. (PRNS Archives.)

The heart of the lifeboat station was its 36-foot motor lifeboat, a wood-hulled, self-bailing, and self-righting workhorse of a boat. The boat pictured, in service through the 1950s and 1960s, is preserved by the National Park Service in the historic station. (PRNS Archives.)

Crews at the lifeboat station remained active, although the number of large shipwrecks had diminished by the 1930s; crews mostly aided smaller craft, especially fishing boats. In 1938, a United Airlines DC-3 ran out of fuel and landed in the water off Point Reyes, eventually drifting onto the rocks. Five died, but two survivors were rescued by the brave lifesavers of Point Reyes.

The lighthouse and lifeboat stations used radio technology as it became available, but few people know the important place of radio history in West Marin County. The Marconi Wireless Company of America, founded by famous inventor/entrepreneur Guglielmo Marconi, constructed the first high-power wireless station here in 1914, blasting long waves across the Pacific Ocean from its transmitting station at Bolinas and receiving at Marshall on Tomales Bay, shown here. (PRNS Archives.)

The "Wireless Giant of the Pacific" was taken over by RCA in 1920, which built a new receiving station at Point Reyes in 1930. From this building, a large staff of radio operators, technicians, and riggers controlled communications through Morse code between Pacific Rim cities and ships at sea. The last official Morse message left this station in 1997. The Point Reyes and Bolinas stations are now within Point Reyes National Seashore. (PRNS Archives.)

Overland travel in Point Reyes posed a hardship for travelers. Residents and visitors alike trod along mile after mile of poor dirt and sand roads, fighting either dust or mud, and opening (and closing) dozens of gates along the way. The standard mode of travel was a buggy or wagon following roads that remain on the same routes as today. Stagecoach service was available to Olema and for special excursions beyond.

The North Pacific Coast Railroad constructed a narrow-gauge railway from Sausalito to Tomales in 1874, making travel to Point Reyes much easier. Originally intended to haul timber from the northern redwood country, the train also transported dairy products, livestock, fish, and passengers on a regular schedule. This photograph shows the depot and a street scene at Point Reyes Station around 1920.

The North Pacific Coast Railroad tracks followed Lagunitas (or Paper Mill) Creek to what became Point Reyes Station, then snaked along the edge of Tomales Bay for points north. Notice the side roads to Olema.

Passengers could be met by a stage at Point Reyes Station and transported to the numerous attractions of the area. Here a group of women and their male companion have chosen bicycles as their mode of exploring Point Reyes.

The automobile changed life all over the world, and Point Reyes didn't escape the coming of the horseless carriage. Motorists braved the old stagecoach roads and sought out the farthest reaches of the point. Here Clara Claussen poses with a Stanley Steamer at her family's ranch on the point.

Automobiles crowd the Point Reyes Station depot—a sign of the times. By 1930, the train tracks connecting to the Russian River had been pulled up, and in 1933, railroading would end in Point Reyes Station.

With cars came the cry for better roads, spearheaded by a group called Marvelous Marin. Citizens of the county passed a bond act in 1925 that resulted in the construction of Sir Francis Drake Highway, a modern, engineered concrete roadway with fine bridges spanning its crossings of Paper Mill Creek. The dedication at Olema drew crowds who were entertained by a marching band from San Rafael High School.

The age of automobiles changed West Marin forever. Trucks now hauled the products of the ranches and farms, and returned with supplies for local stores. Tourism increased, especially during the 1960s and 1970s with the creation of parks in the area. This 1959 motorist is navigating the Tocaloma Bridge on the Drake Highway, which has since been replaced with a wider and less elegant span. (Photograph by D. M. Gunn.)

Four

TOWN AND COUNTRY LIFE

With ranchers, lighthouse keepers, and railroads came towns. Not cities, by any means: this was a humble, agricultural landscape with local ambitions limited to good schools, pretty churches, grand meeting halls, and modest homes. The character of West Marin towns is one of seldom-grand expectations. The towns of the Point Reyes area—Olema, Point Reyes Station, and Inverness—appeared and grew slowly. There were no boomtowns and little fanfare, and everything came together piece by piece. First was Olema, founded by dairy rancher Benjamin Winslow in 1858 with the support of the local Mexican land grantee Rafael Garcia. Olema grew for 15 years until the North Pacific Coast Railroad passed it by; from that time on, Olema stayed as if stuck in time, with a store, a few bars, a couple of hotels, and only a handful of homes. The railroad helped create Point Reyes Station but did not show up with a bang. Where passengers got off to travel two miles overland to Olema, an entrepreneur put up a hotel and bar opposite the depot. By 1900, the town was barely four blocks long, and most of the lots laid out were empty. People built homes but not until the later decades of the 20th century did the surrounding hills get their sparse covering of homes. Inverness could also call the North Pacific Coast Railroad one of its founders but in a different way. The owner of its beautiful woods, meadows, and beaches invested heavily in the railroad and lost. Still the emerging village proved popular with "city folk" who built cottages and played here during the summer. Like Point Reyes Station, the real boom didn't come until the 1970s through the 1990s as the place was discovered again and is now touted by media as a great place to live. What binds these towns is their 19th-century small-town character that has been not-too-carefully preserved. They were not made to be quaint. The towns were saved as the countryside was preserved through the efforts of conservationists, local residents, supportive politicians, and even stubborn landowners. Today the visitor can experience not only the serenity of the open landscape, but also the tiny villages that define it, while the locals continue the old Point Reyes tradition of modest ambitions.

Founded by forty-niner Benjamin Winslow on land purchased from Rafael Garcia, Olema got its name from the Coast Miwok *olema-loke*, or "lake of little coyotes." The little town clustered at a crossroads where the San Rafael Trail met the Point Reyes road. Winslow built a hotel (not visible) and post office (on the right), which he tended beginning in 1859. Later another forty-niner named John Nelson built the Olema Hotel, seen at center.

Known as a place where one could find plenty of bars within its two-block length, Olema had big aspirations in its early days, vying for selection as the county seat and acting as the central community for the Point Reyes ranches. Perhaps these men gathered in front of the Union Hotel had ideas about how to make Olema the great place it once could have been. (Dan Brown collection.)

Construction of the North Pacific Coast Railroad in 1875 and the subsequent establishment of Point Reyes Station to the north left Olema a sleepy crossroads. Despite its new neighbor's eventual dominance, Olema remained a proud but small gathering place for local ranchers and travelers. It was dominated by Swiss immigrants, such as these residents celebrating Swiss independence. (Gilardi family, Jack Mason Museum.)

An important civic institution in Olema was the impressive Druids Hall, built in 1886 and used for almost a century. The handsome building is now a bed-and-breakfast.

Olema's fine schoolhouse, with a meeting hall upstairs, was named Garcia School after the original resident of the area. The schoolhouse, located on the lane to the Shafter Ranch, burned and was replaced in a different location in 1915.

This Catholic church stood proudly up the road from the Olema Hotel. The priest lived in a substantial two-story rectory located a few blocks north of town. The old church was closed in 1923 and was replaced in the 1960s by a modern edifice adjacent to the old rectory.

The family of James McMillan Shafter, a notable California attorney and the owner of a large part of the Point Reyes Peninsula, resided for a century in their estate known as the Oaks, constructed in 1869. James's son Payne kept Thoroughbred horses and maintained a racetrack here. The Vedanta Society owns the property today.

The "squire of Olema," Payne Shafter posed with his family. They are (first row) Payne; his mother-in-law, Mrs. Jackson; and his wife, Helen Jackson Shafter; (second row) Payne's daughter Helen Shafter; his uncle Charles Jackson; daughter Mary Shafter; brother Jim Shafter; and sister Julia Shafter Hamilton.

John Nelson built the Olema Hotel in 1876 and ran it until his death in a buggy accident in 1898. His son Edgar ran it for 40 years, but the heyday was over; during World War II, the building was used as an army barracks and then abandoned. The hotel reopened in the 1970s as the Olema Inn. (Below, Dan Brown collection.)

Fishing on Olema Creek—Quail Hunting

Olema Hotel

OLEMA, MARIN CO., CALIF.

1½ Miles from Tocoloma Station,
N.W.P.R.R

Fishing Season—Steelhead Dec. 15 to Feb. 1st; Trout May 1-Nov. 1.
Quail Shooting—Oct. 15 to Jan. 1.
Deer Shooting—Aug. 1 to Sept. 15.
Beautiful Scenery, Fine Auto Highway. Meals and Hotel Accommodations.

ED NELSON, Proprietor.

The Country Club House, Bear Valley near Pt. Reyes Station, Cal.

San Francisco's exclusive Pacific Union Club built its country club in Bear Valley, a few miles southwest of Olema. Prominent city men used the finely appointed clubhouse from the early 1890s into the 1930s. The buildings were torn down after the war. Nowadays hikers enjoy its location, known as Divide Meadow, in Point Reyes National Seashore. (PRNS Archives.)

Local gamekeepers accompanied all club members on their hunts; ladies were only allowed at the country club during certain seasons. In this photograph, keeper Sam Peporio has bagged a mountain lion, carried by Frank Briones.

BAYWOOD PRESS

A MARIN COUNTY NEWS MAGAZINE

Volume 1　　　Inverness, California, March 15, 1948　　　Number

THIRD ANNUAL RODEO
TO BE HELD AT
BEAR VALLEY RANCH
MAY 23, 1948

Picture by Seth Wood

Bear Valley ranch owner Gene Compton, owner of a San Francisco cafeteria chain, opened his central pasture to the public for a fully accredited Western-style rodeo in 1946–1948. Local cowboys joined professional circuit riders to the benefit of local charities. The new local newspaper, *Baywood Press*, covered the event. Its successor, the *Point Reyes Light*, still publishes weekly; another weekly, *West Marin Citizen*, began publication in June 2007.

The family of Robert Menzies, a San Rafael businessman and enthusiastic botanist, enjoyed a rustic cabin in Bear Valley. The Shafter and Howard families sold a handful of lots along Bear Valley Creek to friends and acquaintances, most of whom created modest vacation cabins, some of which stood into the 1970s. (PRNS Archives.)

Winifred Menzies (left) and a friend display a botanical specimen that today raises the hackles of land managers, both park and rancher: thistle! (PRNS Archives.)

The arrival of the North Pacific Coast Railroad in 1875 signaled the end of Olema's growth and heyday. The narrow-gauge rail line originated in Sausalito (where ferries connected to San Francisco) and headed north via San Anselmo, San Geronimo Valley, and Tomales Bay. The destination was the rich redwood timber of the Russian River area. Bypassing Olema through a trick of geography, the tracks met the head of Tomales Bay at a wide, flat pasture two miles from town.

Mary Black Burdell (left), the daughter of Marin pioneers, owned the property where passengers on the new train line disembarked for Olema and the ranches of Point Reyes Peninsula. Her husband, Galen Burdell (right), a prominent San Francisco dentist to whom she had deeded the land, took opportunity by the horns and developed a town, first called Olema Station, at the former cow pasture.

Galen Burdell laid out a town and erected a hotel and a saloon across from the depot. The place was known as Olema Station, Burdell's, and Marin before the post office settled down as Point Reyes Station in 1891. A. P. Whitney opened the first mercantile in town, seen at right. Swiss immigrant Salvatore Grandi took over the store around 1887 and built tidy cottages behind it for his employees.

Burdell's modest hotel faced the depot and featured an adjoining saloon. He wrote a condition to lots sold in his subdivision, outlawing the establishment of saloons that might compete with his own; the deed restriction was later struck down by the state supreme court.

The North Pacific Coast Railroad deposited residents, visitors, and laborers to Point Reyes Station on schedule. The rail yards occupied the east side of the street, while the hotel, bar, mercantile, and other shops stood facing the tracks. As the Point Reyes area became more popular, excursionists arrived for trips to Bear Valley, Tomales Bay, and the lighthouse.

The first rail depot was a standard, two-story building with quarters above. Regularly scheduled passenger trains competed with the lumber trains headed to San Francisco from the redwood country. This depot was later moved aside and replaced with the depot that stands today and houses the U.S. Post Office.

On Road from Pt. Reyes Station to Inverness Cal

Train travelers connected to Olema by this bridge, which replaced a ferry service over Paper Mill Creek. Earlier, small schooners visited this location and transported, at great risk and rigor, the paper from Samuel P. Taylor's Pioneer Paper Mill until the rail line brought efficiency to local industrial transportation.

HOTEL PT. REYES, PT. REYES STATION, CALIF.

The original A. P. Whitney store, a masonry affair operated by Salvatore Grandi, turned to rubble in the 1906 earthquake. Apparently undeterred by the San Andreas Fault, Grandi's heirs built a larger building at the former location of the Point Reyes Hotel—of brick. This, the largest structure in Point Reyes Station, featured a mercantile, restaurant, and hotel, with other retail outlets on the property.

Common in the late 19th and early 20th century, store owners sold tokens that could be traded for drinks or other items. (Dan Brown collection.)

The saloon next to the Point Reyes Hotel was the gathering place for railroad men, ranchers, merchants, and traveling salesmen. Jim Sam (second from left at table), a Chinese man who had been practically kidnapped from San Francisco as a boy when two Marin ranchers picked him up near the waterfront, became a well-known cowboy, hotel cook, and gambler in West Marin.

The North Pacific Coast Railroad changed owners twice and became known as the North Shore Railroad and, finally, the Northwestern Pacific. Improvements in 1920 included a large engine house (rear) and turntable on the north end of town. Here engines could be maintained and coaches built and repaired, activities that cemented Point Reyes Station as the western Marin/Sonoma rail hub.

Point Reyes Station experienced a building boom in the 1910s as the Point Reyes Cooperative Creamery erected a plant and cottages on the north side of town and the Foresters of America built this grand meeting house in 1915. The Foresters building hosted club events, community meetings, and even movies. It later became a gallery and now hosts studios and apartments. (Richard Velloza collection.)

The dairy industry dominated the West Marin towns. Point Reyes Station was the location of the Point Reyes Cooperative Creamery, where member dairymen processed their milk from the many dairy ranches in the area. The state-of-the-art facility produced butter, cheese, casein, and other dairy-based products. Here co-op members Bill Hall (left) and Joe Adams work the churns.

A few local dairies bottled their milk at the ranch, which was marketed in the area. (Dan Brown collection.)

As it was a rail town, Point Reyes Station residents set their watches on the distant whistle as the morning train came around the bend into town. The place would bustle for a while, and then quiet descended on the place until the next train. The station's water tank provided for the ever-thirsty steam trains.

Point Reyes Station was the only West Marin town to be laid out on a grid designated with numbers and letters of the alphabet, as befit the standard American practice at the time. It was a working-class town with merchants, creamery workers, and rail employees making up the populace. Here a couple mugs for the camera on B Street. The town's livery stable rises in the center background. (PRNS Archives.)

By 1927, Point Reyes Station was booming. This view shows the transfer platforms where freight from the north was changed from the narrow-gauge to standard-gauge trains (left), the bustling market town dominated by the Grandi Company in the distance, and the Point Reyes Emporium at right. (PRNS Archives.)

Swiss immigrant Pietro Scilacci left the employ of the Grandi Company in 1898 and built his own store on the north side of town. The two families competed for the next four decades; even the post office bounced back and forth between merchants, depending on the current political party in power. Calling his place "The People's Store," Scilacci offered a new experience for local shoppers. (Left, Dan Brown collection.)

Point Reyes Station's first school was built in 1879 on the hill above town. Named after the pioneer owner of the property on which the town stood, the Black District School's classroom soon overflowed as the town grew. This class group included the children of dairy ranchers, rail workers, and merchants.

A fine new school, also called Black School, was built in 1905 on a flat lot in town. The impressive architecture illustrated the town's prospects at the time. The 1906 earthquake damaged the schoolhouse but not until the 1950s was the venerable institution replaced by the modern West Marin Elementary School, located opposite the pioneer schoolhouse up the hill.

The 1906 earthquake, which devastated San Francisco, also caused extensive damage in the Point Reyes area. Buildings fell, chimneys toppled, and water tanks crashed to the ground. Miraculously, only two fatalities occurred, both in the town of Tomales. The most famous local image is this one: the morning North Shore Railroad train at Point Reyes Station has been knocked on its side. Crews righted the locomotive, but tracks, trestles, and fills all over West Marin had to be repaired before service could resume. The Point Reyes Hotel, in the background, survived the temblor, but its neighbor, Salvatore Grandi's pioneer mercantile, was reduced to rubble.

One of the most dramatic displays of fault line offset occurred on the Levee Road crossing the marsh at the head of Tomales Bay. The road went straight through before the quake, but the west side (in the distance) was shifted north by about 20 feet. The filled roadway had been sitting on top of mud since it had been built in 1876. Local crews fixed the road, which was and still is an important artery connecting Point Reyes Station with Point Reyes proper.

Although the longtime impression that Olema was the epicenter of the quake has been disproved by modern scientific methods, it is still considered that the greatest earth movement occurred here. Noted botanist Alice Eastwood posed along the fault trace at the south end of Tomales Bay.

Alexander Baily's boat pier at Inverness, once straight, showed the effects of the earthquake. As lands on the west side of the bay shifted north and bay mudflats wiggled like Jell-O, the posts holding up the pier moved with the mud they had been driven into. The photograph is a textbook example of tectonic movement in a shallow-water setting. Baily made basic repairs, but the pier remained curved.

A wide bend in Lagunitas (or Paper Mill) Creek west of Point Reyes Station has long been known as White House Pool; a white farmhouse stood here for a century. White House Pool has long been a favorite fishing spot for solitary fishermen and for large groups such as this one, the California Anglers Association. Salmon, steelhead, and sturgeon once frequented this stretch of creek and are now coming back after a downturn.

Near White House Pool, the community of Inverness Park was founded in 1911. Central to that community was the trout hatchery, a popular stop for visitors to the area.

The community of Inverness was born from one man's attempt to regain a lost fortune. James McMillan Shafter, the prominent owner of thousands of Point Reyes acres, invested generously in the North Pacific Coast Railroad. When it didn't pay, he turned to real estate development, founding Inverness (named for his old family homeland in Scotland) in 1889.

Real estate agents attracted potential buyers to Inverness with camping trips and promises of a grand hotel. City people enjoyed setting up their tents on potential building lots, and a few actually bought; but Inverness was slow to take off. By the 1920s, it had established its reputation as a cozy summer resort, scattered with quaint cabins but sans a first-class hotel.

Attilio Martinelli built the first store in Inverness in 1900 and put it back together after the 1906 earthquake sent its second floor to the public roadway. The Inverness Store catered to tourists, locals, and ranchers, and still does today, although now in a newer building across the street. Martinelli's venerable storefront still dominates "downtown" Inverness.

Although a relatively quiet village, Inverness had its own candy store as befits a beach town. This c. 1910 view is to the south, with the Inverness Store obscured by trees, and the candy store looms on the corner of Inverness Way. Vladimir's Czech restaurant inhabits the corner today; the candy store, to the chagrin of generations of children, burned in 1948.

The Inverness Post Office was established in 1895 in this charming log cabin opposite founding postmaster Alexander Baily's home, The Gables. The 1906 earthquake toppled the little gathering place, which reopened in an annex to the Inverness Store.

Many summer residents reached their cabins courtesy of Ben Pedranti's various stage lines, although others patronized the opposition line operated by James Reeves, owner of the Hotel Inverness. Horse-drawn wagons met the trains at Point Reyes Station and delivered the passengers to their doorstep. Ben's Auto Stage was an improvement, whisking Invernessians over the rutted dirt road in record time.

An Inverness tradition since 1904, the Fourth of July Races challenged children and adults alike, male and female, to footraces, three-legged races, and other fun, always prefaced by a reading of the Declaration of Independence. Although the events have moved from the main street to Inverness Way at the firehouse, multiple generations still compete and share memories of races past.

Fourth of July festivities included boat races culminating in a mass community picnic at Shell Beach, a few miles north of Inverness. The water lured most families to Inverness, where swimming, sailing, and fishing took up entire summers generation after generation.

Sophisticated city people, the majority from Berkeley (and the majority of those were University of California professors and their families), built houses for their summer use at Inverness. Those who didn't could stay at one of many small hotels and lodges, such as Mary Burris's Highland Lodge (pictured above).

Ranging from simple board-and-batten cottages to fine homes designed by Bernard Maybeck and Julia Morgan, the woodsy setting and genteel yet highly intellectual inhabitants made for a unique community. Today architectural historians regard Inverness as the best intact example of a California craftsman, shingle-style neighborhood remaining in the nation.

Not all Inverness families were summer residents from the cities. True locals included those who provided services, including carpenters, plumbers, stonemasons, shopkeepers, and the Hom family, operators of the local laundry. The Homs raised a large family in Inverness, and many of the kids ended up going to a university or into successful trades. Other all-year residents were largely Portuguese or Italian.

The Inverness School was founded in the loft of a horse barn and rooted from its roost by the 1906 quake. Town fathers had this shingled one-room school erected two years later on the Inverness mesa, which has since been replaced with a modern elementary school.

Brock Schrieber came to Inverness as a young man with the sea in his blood. He built fine wooden boats and constructed this boathouse and pier, long a gathering place for the summer people. Brock took care of his clients' boats over the winter and became the source for information on boating and Tomales Bay. He lived to be an old man in this community that he loved.

Brock's summers were dominated by his popular motor cruises of the bay. His boats, the *Kemah* and the *Queen*, ferried families to Shell Beach and beyond: to the clam beds, to favorite fishing spots, to Hog Island; anywhere you wanted to go, Brock could arrange it. Here a group of dignified women disembark at Brock's Boathouse, no doubt having thoroughly enjoyed their excursion on Tomales Bay.

Many a young man or woman learned the art and pleasure of sailing on Tomales Bay during Inverness summers. A dedicated community of sailing enthusiasts brought their neat wooden sloops and yawls, and raced, visited beaches, or just lolled about. The Inverness Yacht Club, founded in 1912 and revitalized in 1949, has kept the tradition going with a strong youth sailing program and exciting races throughout the summer.

Ah, but it is those secluded sandy beaches, where friends can gather and the water is warm (at least compared to the icy Pacific!), that most define Inverness life. Once the shores were scattered with changing cabins, back when there was more to change into. As full-length suits gave way to bikinis (with an interlude of skinny-dipping in the early 1970s), the pleasure of the swim has changed not a bit.

Five

An Invigorating Landscape

The scenic Point Reyes Peninsula has attracted visitors since the days of the Mexican dons when Warren Joseph Revere hunted elk with grantee Rafael Garcia. Revere commented on the stark beauty of the place, as did most other early visitors. The area's combination of green pastures, ocean bluffs, forests, and beaches, all set on a spectacular coastline, came to be known in Gold Rush San Francisco before too long. Tourists began to arrive with the North Pacific Coast Railroad in 1875, which whisked passengers on ferries and train to Paper Mill Creek and the shores of Tomales Bay. Arriving at various depots and whistle-stops along the way, sightseers, hikers, and hunters could catch a stagecoach to a favorite destination or just walk off into the wilderness. Popular sites included the Point Reyes lighthouse, Bear Valley, and Tomales Bay beaches. Charles Webb Howard opened his vast Bear Valley lands to hikers, while the Pacific Union Club opened an elegant hunting resort there. The area's popularity and beauty inspired the creation of the town of Inverness, where city people could have a getaway cabin for the summers. Long and short visits to Point Reyes became family traditions, with many generations continuing the trek to this day. The automobile increased access, prompting new highways and increased visitor services like gas stations and restaurants. Despite the fact that most of the land was private, there were places to go on an outing to keep people happy; even a long drive in the country could be a spectacular way to spend a sunny day. The postwar population boom in the Bay Area increased the demand for recreation, and a few small county and state parks were developed. Most visitors during the 1950s and 1960s came to sunbathe and swim, with few opportunities to hike and explore because of the private property (most hikers went to Mount Tamalpais). Not until the opening of Point Reyes National Seashore did the public finally have free access to thousands of acres, bringing a new generation of hikers to Point Reyes. The many opportunities for recreation at Point Reyes were largely created by nature: the beaches, forests, hills, wildlife, and so on. Development of motorized types of recreation, like speed boating, dirt biking, and car racing, was kept at bay. Over the years, most people have come to Point Reyes for a little peace and quiet. The locals like it that way.

Excursions by buggy offered glorious views and occasionally thrilling rides over ridges and along the ocean bluffs. The group pictured above, from the Pacific Union Club, was enjoying the scenery in Bear Valley near that organization's country club. Landowner Charles Webb Howard opened the dirt road connecting Olema with the ocean in the late 1800s, bringing picnickers and hikers like those seen below. Today hikers, horsemen, and bicyclists enjoy the old dirt road, which is now known as the Bear Valley Trail in Point Reyes National Seashore. (Below, PRNS Archives.)

Accommodations for tourists in the Point Reyes area appeared shortly after the train service started in the 1870s. Joseph Bertrand built his finely appointed country hotel in Tocaloma on Lagunitas Creek in 1889, replacing a smaller one that had burned. The hotel catered to hunters, fishermen, and hikers, all of whom could step off the train in front of the building. Payne Shafter, son of Point Reyes landowner James McMillan Shafter, offered excursions from Tocaloma, the closest train stop to Olema, to the varied attractions of the area. Giuseppe Codoni's fine dairy ranch faced the hotel across the creek, where his great- and great-great-grandchildren still live and run cattle. The hotel burned in 1916 and was replaced with a more modest building. (Above, McIsaac family collection.)

TO EXCURSIONISTS.

Parties Furnished at

"TOCALOMA,"

ON

North Pacific Coast Railroad, in Marin County,

WITH TEAMS AT MODERATE RATES,
FOR ALL POINTS BEYOND.

Romantic rides down Bear Valley to the Ocean Beach. To Point Reyes, where the Light House is located. To Tomales Bay, where Abalone Shells abound in variety above danger. To Bolinas, where fine Sea-bathing is found.

All within Easy Reach of San Francisco, to and fro, the Same Day.

Apply in Person, or by Letter, to

P. J. SHAFTER,
Olema, Marin County, Cal.

Early Inverness visitors especially enjoyed boating on Tomales Bay, which continues today as a favorite pastime. Brock Schreiber, who operated a boathouse replete with rentals; boat storage and repairs; and daylong excursions, had three motor launches with which to transport visitors to destinations "up the bay." Favorite stops included Shell, Pebble, Heart's Desire, and Sewing

Machine Beaches. Schreiber often took his passengers to the mouth of the bay or to Hog Island. A party could be dropped off and picked up later or could enjoy a slow cruise the length of Tomales Bay. This photograph shows happy passengers crowded aboard the *Kemah* while leaving Inverness, with Mount Vision in the background. (PRNS Archives.)

Large gatherings were common in the days of train travel, with families and friends organizing picnics and camping outings to favorite Point Reyes places. This well-dressed group gathered at Heart's Desire Beach on Tomales Bay early in the 20th century. (PRNS Archives.)

While leisurely pursuits dominated recreation on Tomales Bay, sometimes the competitive spirit took to the water. Sailing races have been a long tradition at the Inverness Yacht Club, and this group of rowers races as part of Inverness's Fourth of July events. (PRNS Archives.)

Good fishing drew thousands of visitors to the area. A favorite of locals and outsiders was White House Pool, where a local developer constructed wooden walkways along the shore to accommodate the crowds. The writing on the postcard at top says, "Trout and Steelhead Fishing in Famous White House Pool, Inverness . . . the ideal pleasure resort of California." In the picture below, men and dogs line up with their catch at a local ranch.

Many summer residents owned small boats, which they rowed, sailed, or motored to Shell Beach and beyond. (PRNS Archives.)

The ocean has always been a popular destination. These young women enjoy the rocky shore at the western end of Bear Valley early in the 20th century. (PRNS Archives.)

Organized recreational opportunities included a major Boy Scout camp in Second Valley at Inverness during the 1920s. The troop commandeered a large field where they set up tents, a canteen, a flagpole, and marching ground. They used this location as a starting off point for long hikes. Later the camp moved to Bear Valley.

Hiking (or "tramping" in the old days) has long been the favorite activity at Point Reyes. It would not be unusual for a party of friends to get off the train at Tocaloma or Point Reyes Station, hike all the way to the ocean, and be back for dinner. The open fields of the ranches made for especially good "tramping."

Swimmers enjoyed the relatively warm waters of Tomales Bay; it took a brave person to swim on the ocean side of the peninsula.

Local residents constructed changing houses and small sleeping cabins along the Inverness shoreline. A few of these buildings remain today. The long pier was Brock Schreiber's, with Alexander Baily's in the distance. Black Mountain looms over the scene. (PRNS Archives.)

The ocean coast drew surf fishers. Other family members could walk the beaches as the fisherman concentrated on his duties. (PRNS Archives.)

Shell Beach remains a favorite of locals and visitors alike. Now part of Tomales Bay State Park, scenes like this are common, with hikers and boaters joining together on a sunny summer day.

As the San Francisco Bay Area grew after World War II, demands for recreational opportunities increased. This map shows population centers in relation to the Point Reyes Peninsula and a graph predicting a population boom between 1930 and 2000. (PRNS Archives.)

Officials in Marin County responded to the demand for recreation areas by creating a system of county parks in the 1940s and 1950s. Two were established on Point Reyes: McClures Beach on Tomales Point and Drakes Beach. Visitors to the latter passed through an active dairy ranch on a dirt road, paying "two bits" to the rancher for permission to pass.

The National Park Service (NPS) had pinpointed Point Reyes as a potential park as early as 1935 when NPS planner Conrad Wirth recommended investigation of the area. In the 1950s, the park service, now with Wirth at its helm, initiated a recreation survey of the Washington, Oregon, and California coasts (right). Every part of the shoreline that had recreation potential or scientific interest was assessed. The report found that more than a third of almost 1,500 miles of shoreline in private hands possessed "important remaining opportunities for recreation and other public purposes." Point Reyes was tapped as one of five areas considered to be of "national significance." Its beaches, hills, and waterways had been private property since the days of Mexican land grants. At the time the survey was released, most of Point Reyes was posted as "No Trespassing." (Both, PRNS Archives.)

Even before the Pacific Coast Recreation Area Survey was released in 1959, developers were dividing up the hills and sand spit at Limantour Beach. With a proposed freeway reaching Tomales Bay and a booming Bay Area population, Point Reyes was the logical "new frontier" for suburbs and second homes. These developments alarmed conservationists and helped start a movement to protect local scenic areas. (PRNS Archives.)

Another cause for alarm was a logging operation on Inverness Ridge, launched in the mid-1950s. The Sweet Lumber Company gained rights to thousands of acres of virgin Douglas fir on the ridge and constructed a lumber mill at Five Brooks in the Olema Valley. Logging and subdivisions only increased the cries for protection. Today the sawmill site is a trailhead in Point Reyes National Seashore. (PRNS Archives.)

Six

A National Park Arrives

The public demand to create more accessible recreation areas was a result of the population boom and influx of families to cities and suburbs in America following World War II. But as early as the 1930s, the National Park Service had already identified unspoiled areas of natural beauty and diversity to be set aside for public enjoyment and use, including Point Reyes. In response to public need, government representatives drafted legislation in the late 1950s to create one of the country's first national seashores. To halt logging, planned freeway construction, and the fabrication of bedroom communities, conservation groups rallied support for the legislation. Most of the peninsula, 53,000 acres, was to be included in the boundaries of a new national park, Point Reyes National Seashore. A major sticking point was government purchase of these primarily private lands on the peninsula, including a number of dairy and cattle ranches. The original concept of national seashores was to provide recreation and beach access near densely populated areas. With the greater San Francisco Bay Area in reach, Point Reyes National Seashore was perfectly situated to attract boaters, fishermen, horseback riders, campers, cyclists, sightseers, picnickers, and hikers. The first plan proposed constructing roads, trails, and facilities for these recreational uses. Opposition was fierce—initially the Marin County Board of Supervisors objected to the park along with local residents and ranchers, many of whom had labored for generations to become landowners. Through congressional hearings and compromises, opposition abated, and on September 13, 1962, Pres. John F. Kennedy signed the act creating Point Reyes National Seashore. It took 10 years to purchase the mosaic of private lands that make up the national seashore today. In that span, concerned citizens and environmental groups, bolstered by the Wilderness Act (1964) played a key role in changing the seashore's plans for recreational development. In 1976, Pres. Jimmy Carter designated 25,370 acres of Point Reyes land as wilderness, disallowing roads, vehicles, and other constructs in the wilderness areas, channeling efforts into environmental restoration. In the years since the seashore's creation, the National Park Service and its partners have taken on complex resource management, shaped visitor education programs, and integrated themselves with the local communities. In the last decade, park visitation has exceeded two million people annually. Surrounded by federally protected lands, the historic towns of Olema, Point Reyes Station, and Inverness remain relatively undeveloped, retaining much of their 19th-century character.

California's 1st District Representative Clement Woodnutt Miller, shown here in an official 1960 portrait, was a resident of Marin and owned a summer cottage in Inverness where he enjoyed time with his family. Soon after taking office, Miller and Sen. Clair Engle cosponsored the first bill to create one of the first national seashores at Point Reyes. Riding out the years of ups and downs in Washington to establish a new type of federal park, Miller skillfully orchestrated political alliances and compromises among Congress, the Department of the Interior, Marin County stakeholders, and local landowners. In 1962, the law authorized the Secretary of the Interior to establish Point Reyes National Seashore "in order to save and preserve, for purposes of public recreation, benefit and inspiration, a portion of the diminishing seashore of the United States that remains undeveloped." Tragically, Miller died in a plane crash a few weeks after his dream of Point Reyes National Seashore was realized. He lies at rest within the park on a bluff overlooking the seashore he fought to protect. (PRNS Archives.)

HONORING LAUREL REYNOLDS and MINDY WILLIS

THE POINT REYES NATIONAL SEASHORE FOUNDATION
cordially invites you to attend
A San Francisco Showing of the Unique Point Reyes Film

» *An Island In Time* «

Morrison Auditorium
California Academy of Sciences
Golden Gate Park, San Francisco

Wednesday, June Eighth
Eight Thirty
Coffee Served at 8 P.M.

This film will be available for distribution to interested groups and organizations.

San Francisco Chronicle columnist Howard Gilliam aptly named the peninsula an "Island in Time." The moniker was used by Laurel Reynolds and Mindy Willis for their documentary film on Point Reyes. Gilliam's book of the same title, published by the Sierra Club in 1962, was sent to every member of Congress. With captivating photographs by Philip Hyde, the book and film promoted awareness of the peninsula's unique beauty and brought publicity to the authorization campaign. (PRNS Archives.)

Activist Barbara Eastman, pictured at right, was among the founding members of the Point Reyes National Seashore Foundation. The organization built a local constituency and promoted books, films, and articles to boost support of the park legislation. Eastman took special delight in guiding government officials, leaders, and the press on promotional field trips to show off the impressive landscapes and biodiversity of Point Reyes. (Eastman family.)

This headline ran in the weekly West Marin paper, the *Baywood Press*, on July 8, 1958, ten days after the *San Francisco Chronicle* broke the story about a new "U.S. Seashore Park" proposal at Point Reyes. Immediate opposition included Marin County, who stood to lose a large tax base, and local ranchers who were initially upset over threats to their land ownership and livelihood.

In 1961, scores of people weighed in at the congressional hearings to present arguments both for and against the establishment of Point Reyes National Seashore. Dairy farmers Zena Mendoza-Cabral (shown here) and her son, Joseph Mendoza, testified that they feared losing everything they had worked generations for on their 1,000-plus-acre ranches on the point. Today the family still operates three dairy ranches in the area. (PRNS Archives.)

This *Possible Development Layout* for the seashore was proposed by the National Park Service in 1961. The plan proposed building a funicular railway above Tomales Bay, drive-in campgrounds at Bear Valley and the southern area of the park, and lake fishing accommodations above Double Point. Pressure to designate these areas as wilderness lands were channeled by an organized conservation movement concerned with ecological impacts. Their concerns and the lack of development funds took precedence over the original recreation plans. (PRNS Archives.)

Pres. John F. Kennedy is shown handing Rep. Clem Miller the pen he used to sign the act authorizing the establishment of Point Reyes National Seashore on September 13, 1962. Standing from left to right are Rep. Wayne Aspinall, Rep. J. T. Rutherford, Secretary of the Interior Stewart Udall, Rep. John Saylor, Sen. Alan Bible, Sen. Hubert Humphrey, Sen. Clair Engle, Rep. Clem Miller, unidentified, Rep. Jeffery Cohelan, unidentified, and Sierra Club president David Brower. (National Archives.)

Though never constructed, this drawing illustrates an early design concept by the National Park Service for recreational use of Limantour Spit. This alternative envisioned damming up the estero to create a beachfront and the building of an expansive visitor center, parking lots, canoe rentals, picnicking shelters, and boat tours. (PRNS Archives.)

Secretary of the Interior Stewart Udall (left) escorts First Lady Mrs. Lyndon Johnson (center) in a shoreline toe-dipping at Drakes Bay, along with California governor Pat Brown (right). Lady Bird Johnson arrived by helicopter to speak to a large crowd gathered on a fall day for the official dedication ceremony of Point Reyes National Seashore on October 20, 1966. (PRNS Archives.)

This flyer was created as part of Save Our Seashore (SOS), a massive petition-signing campaign conducted in 1969 that sent over 450,000 signatures to President Nixon. With time running out to purchase the remaining lands necessary to complete the seashore, SOS chairman Peter Behr, with support from other conservation groups and citizens, set in motion the presidential politics that released the Land and Water Conservation Funds to complete the property purchases. (PRNS Archives.)

One of the first Point Reyes National Seashore staff photographs was taken in front of the park headquarters in Bear Valley in 1966. From left to right are (first row) chief ranger Gordon Patterson, Howard Knight, Doris Omundson, Ron Autri, Dan Stout, and Lee Otter; (second row) Harry Wills, unidentified, superintendent Les Arnberger, and Robert Barbee. (PRNS Archives.)

Bishop pine, Douglas fir, and lush ferns provide a haven for hikers on the peninsula who can pause on the trail to enjoy magnificent views of Tomales Bay, Drakes Bay, or the Pacific Ocean. The great diversity of habitat within 70,000 acres of park land—forest, grasslands, dunes, scrub, beaches, and marshes—supports over 900 known species of vascular plants, 490 bird species, and nearly 200 species of mammals, fish, and reptiles. (PRNS Archives.)

Mounted park rangers, as seen here greeting park visitors, were a common sight to hikers with the establishment of the national seashore's Morgan Horse Farm in May 1970. The hearty and even-tempered Morgan horses, bred for ranger patrols, along with the feed barn, tack room, and horse and blacksmith shop exhibits, were the centerpiece of interpretive activities at Bear Valley for many years. (PRNS Archives.)

A school group listens to an interpretive talk by park technician Doris Omundson outside the original Bear Valley Information Center around 1967. Omundson was the first woman to wear an official park service uniform at Point Reyes National Seashore and assumed a major role in interpretive operations, running the Environmental Studies Area Program. (PRNS Archives.)

A replica Coast Miwok village was constructed at Bear Valley in 1976. The project was a joint effort of the National Park Service bicentennial program, the Miwok Archaeological Preserve of Marin, and numerous dedicated volunteers. Lanny Pinola (right) was a park interpreter and a member of the Federated Indians of Graton Rancheria, which includes Coast Miwok and Southern Pomo tribes. The tribes used the site for ceremonies and still hold annual festivals there. (PRNS Archives.)

121

The Point Reyes lighthouse had been operating for 105 years when it was transferred to the care of the National Park Service. Following some structural repairs in the mid-1970s, 53,000 visitors ascended the 304 stairs to see the light up close during 1975, the first year it was open to the public. Park ranger Armando Quintero is pictured here inside the two-ton Fresnel lens with its numerous glass prisms. The lens is rotated by manual pulley weights (much like a giant cuckoo clock) regulated by intricate brass clockworks at the lens base. The small electric light inside the lens, which replaced the earlier oil-burning wick, is magnified through the prisms. Each lighthouse had a unique flash pattern as the lens rotated that was known to ships at sea, providing them with bearings. (Photograph by Dewey Livingston.)

In the 1970s, the seashore struggled to keep up with the demand for day trips and overnight camps to teach environmental awareness to children. A World War II Quonset hut and small cabins were set up in 1975–1976 at Laguna Ranch to facilitate an education center, which was named for Congressman Clem Miller. The nonprofit Point Reyes National Seashore Association raised funds and replaced the hut with a much-improved center in 1987. Since its establishment, the association has raised millions of dollars to support park education and environmental projects. (PRNS Archives.)

Park supporter William Field of Nicasio bequeathed $750,000 to construct the Bear Valley Visitor Center, a donation matched by the Marin Community Foundation. Echoing the design of many historic barns in the area, the award-winning center opened in 1987, featuring exhibits, a bookstore, and visitor information services. (PRNS Archives.)

Point Reyes Station turned into a sleepy agricultural town after the pullout of the Northwestern Pacific Railroad in 1933. As highway traffic increased in the 1950s, the town and its neighbors began serving tourists again. Bars, cafés, and soda fountains lured locals and tourists alike. This photograph was taken in 1968.

Toby Giacomini (right) arrived in Point Reyes in the early 1940s and established a successful trucking and feed business. His son, Chris (left), eventually took over part of the business and helped his father transform an old lumberyard on the main street of Point Reyes Station into the popular and eclectic Toby's Feed Barn.

An influx of optimistic young people into West Marin in the late 1960s and early 1970s led to the establishment of a unique community center called the Dance Palace. Founded by a group of dancers and musicians, the living room–like performance space evolved into a full-blown community center, offering concerts, theater, classes, children's summer camp, senior activities, and community meetings, among other things. (Photograph © Art Rogers/Point Reyes.)

The West Marin Lions Club hosted a 4-H livestock show in 1950 that soon grew to include a parade, ball, and community barbecue in Point Reyes Station. Dubbed Western Weekend, the parade draws spectators from all over the Bay Area and features everything from local kids on ponies, to well-disciplined marching bands from "over the hill." (Photograph by Dewey Livingston.)

Disaster struck the Point Reyes area early on January 4, 1982. Rains came and seemingly never stopped—dumping 10 inches on Inverness Ridge overnight, sending a deluge that gathered soil, rocks, downed trees, and other debris thundering down the canyons. Inverness and the Point Reyes ranches were hit especially hard, cut off from help for days. Dozens of homes were destroyed or damaged.

Although they are located on the foggy coast, fire is a threat to West Marin communities. In October 1995, a smoldering illegal campfire ignited on Inverness Ridge's Mount Vision. By the time it was contained, the Vision fire had consumed over 12,000 acres and 45 houses. Ninety percent of the acreage was within Point Reyes National Seashore, which sent an army of experts to deal with rehabilitation and study. Most of the houses near the summit of Drakes View Drive have been rebuilt. (PRNS Archives; photograph by Wende Rehlaender.)

In a case of "all things come around," the Point Reyes area has become a focal point for healthy and local food initiatives, drawing "foodies" from around the world to sample its artisan cheeses, grass-fed beef, organic vegetables, and range eggs. The place was abuzz in 2005 when England's Prince Charles and Camilla, Duchess of York, spent a few nights here and sampled the local fare. The Point Reyes Farmers Market, while small, is crowded every Saturday during the summer. (Photograph by Steve Quirt.)

With local tourism evolving into food-oriented attractions, the historic dairy and beef ranches preserved within Point Reyes National Seashore have gained a new, appreciative audience. All of these ranches are operated by local families that have lived here for generations. Some dairies are now organic, and other activities include oystering; raising goats and poultry; and egg production. A recent National Park Service initiative supports sustainable farming in parks and the preservation of the nation's cultural landscapes. (Photograph by Dewey Livingston.)

Across America, People are Discovering Something Wonderful. Their Heritage.

Arcadia Publishing is the leading local history publisher in the United States. With more than 4,000 titles in print and hundreds of new titles released every year, Arcadia has extensive specialized experience chronicling the history of communities and celebrating America's hidden stories, bringing to life the people, places, and events from the past. To discover the history of other communities across the nation, please visit:

www.arcadiapublishing.com

Customized search tools allow you to find regional history books about the town where you grew up, the cities where your friends and family live, the town where your parents met, or even that retirement spot you've been dreaming about.